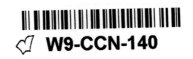

howard bjornson

weeds

CHRONICLE BOOKS

SAN FRANCISCO

Library of Congress Cataloging-in-Publication Data:
Bjornson, Howard.
Weeds / Howard Bjornson.
p. cm.
ISBN 0-8118-2721-6
1. Weeds Pictorial works. 2. Flowers Pictorial works. I. Title.
SB611.B56 2000
632'.5'0222—dc21 99-40234
CIP

Front cover: nodding wild onion, *Allium cernuum*
Front flap: tree-of-heaven, *Ailanthus altissima*
Back cover: bur sedge, *Carex grayi* var. *hispidula*
Back flap: smooth sumac fruit, *Rhus glabra*

Howard Bjornson Studio
300 N. Ashland Avenue
Chicago, IL 60607
www.howardbjornson.com

Designed by VSA Partners
Printed in Hong Kong
Haikus composed by Howard Bjornson,
Susan Bjornson, and Alisa Wolfson

Distributed in Canada by
Raincoast Books
8680 Cambie Street
Vancouver, B.C. V6P 6M9

10 9 8 7 6 5 4 3 2 1

Chronicle Books
85 Second Street
San Francisco, CA 94105

www.chroniclebooks.com

TO Susan, my wife, whose botanicals got mINE started
to Linda, my rep, for supporting a personal vision without cereal bowls or bEER pours
to Mike, my keen-eyeD assistant, for SEEing so many weeds
I would have only stepped on and to Jamie and Alisa, for this design.
thank you

one man
sees a weed
the same
weed to
another
maybe
a flower

one man
sees a weed
the same
weed to
another
maybe
a flower

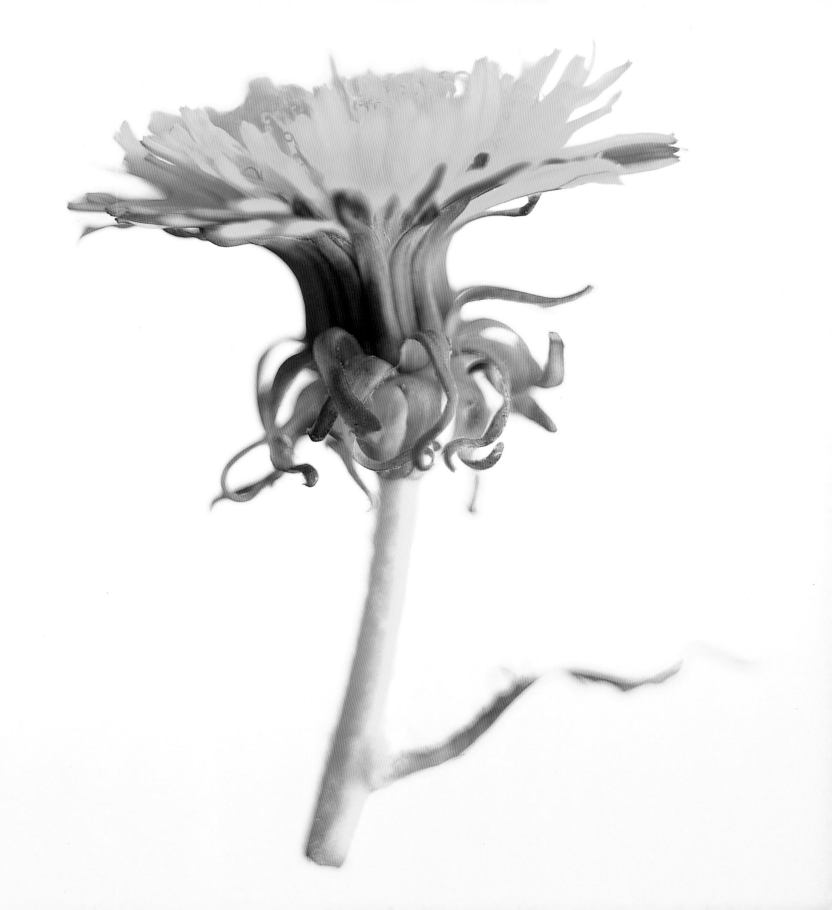

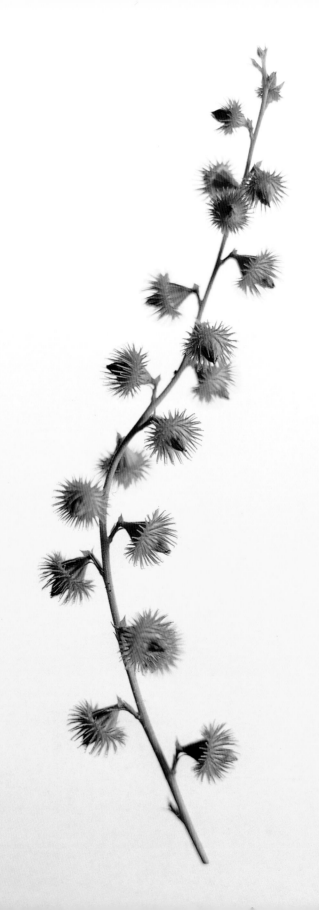

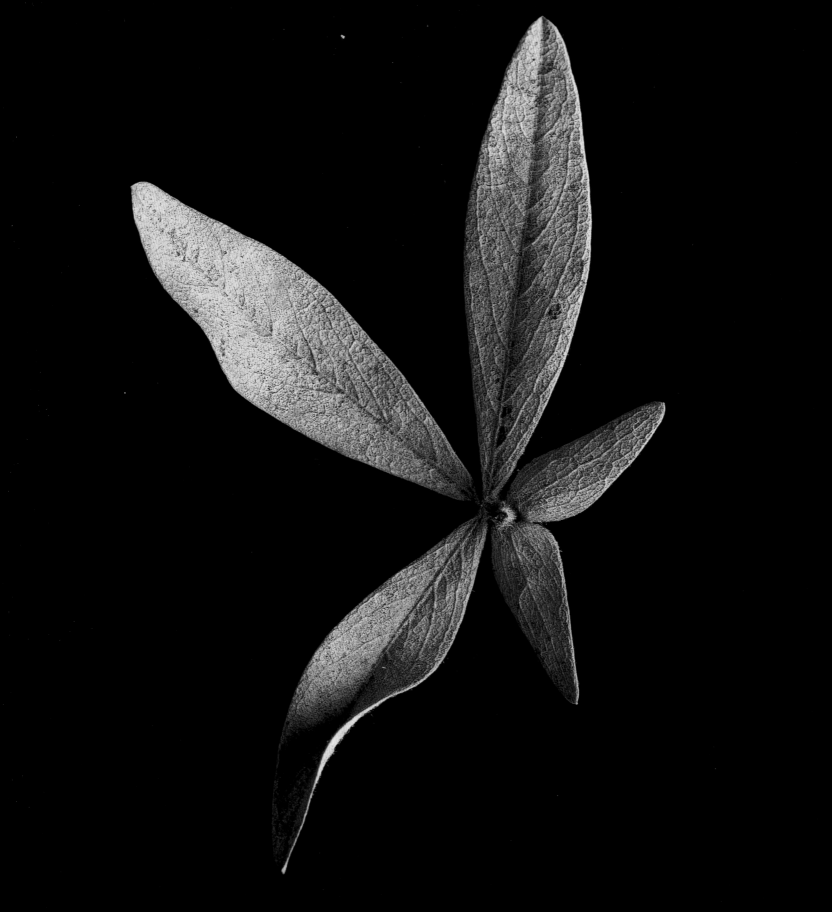

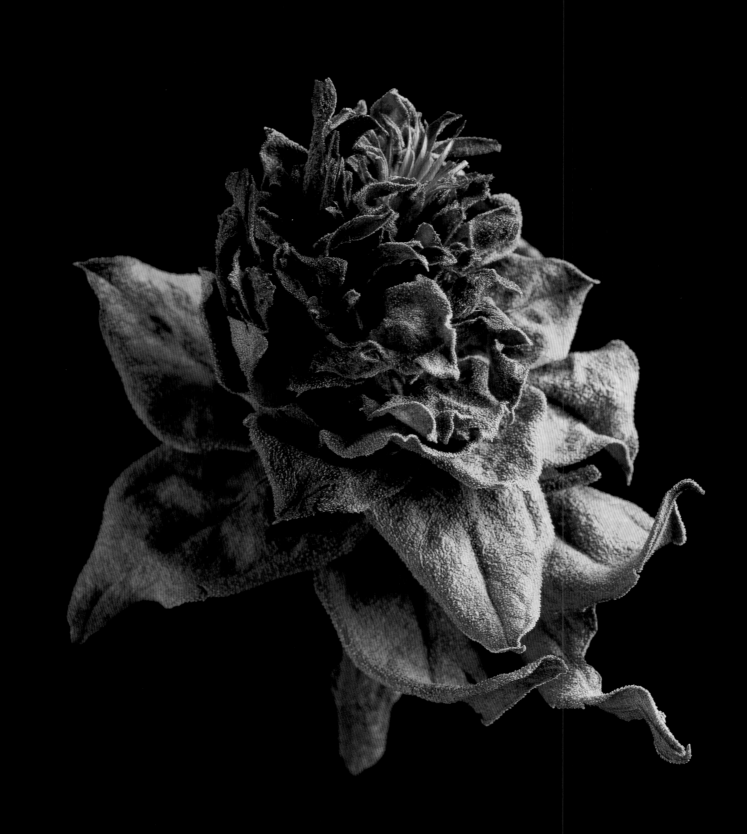

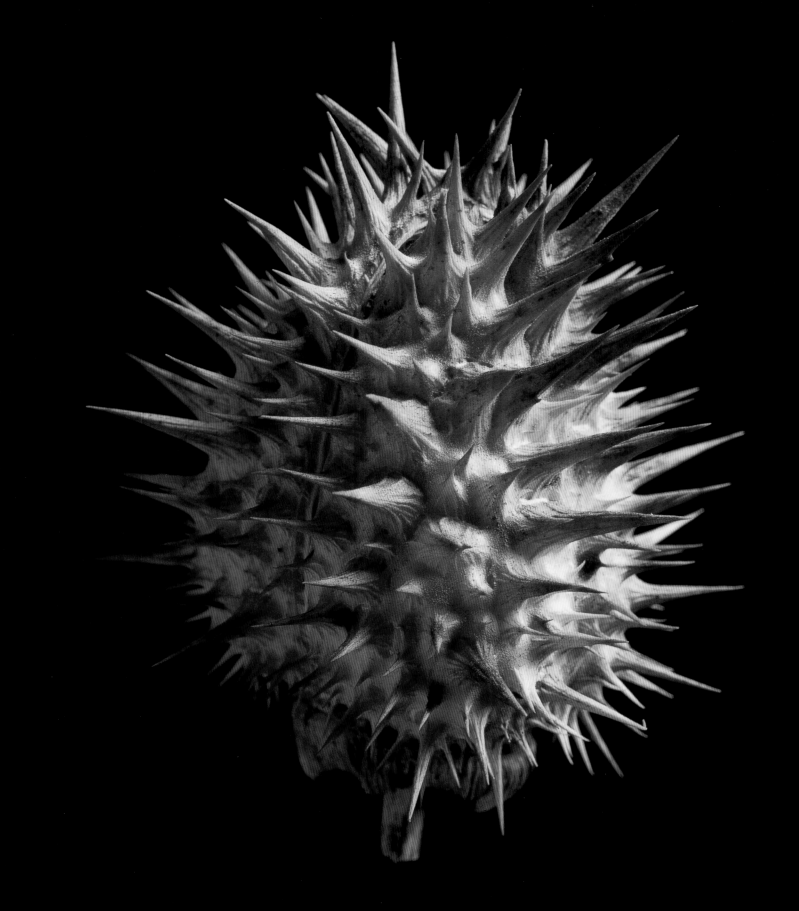

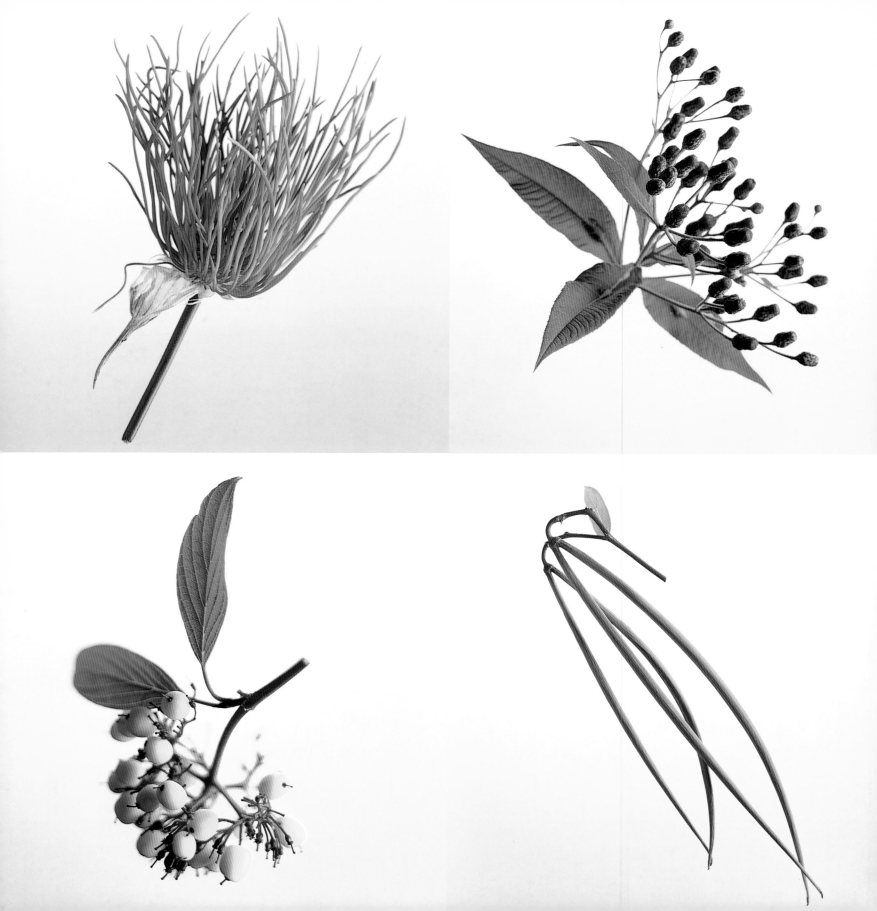

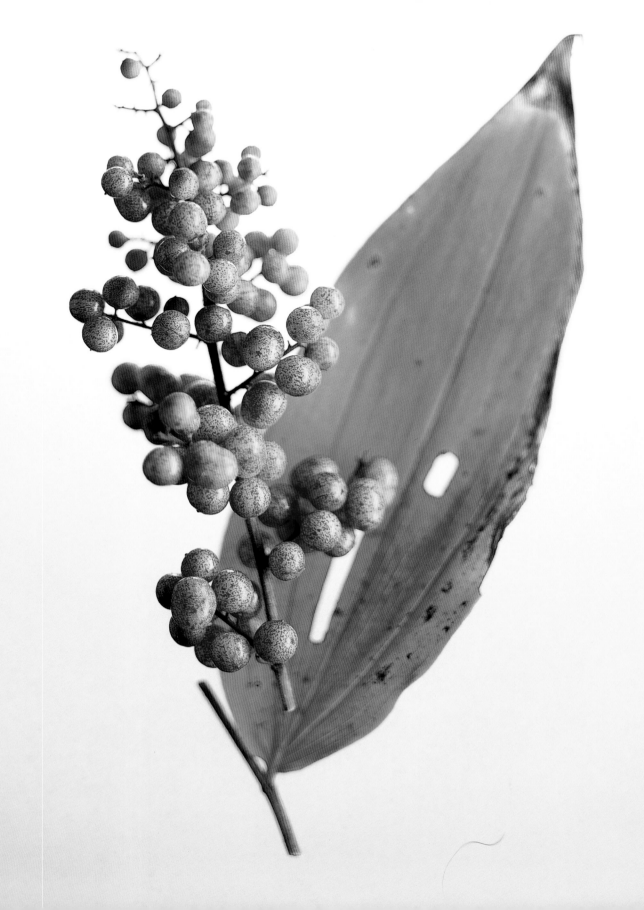

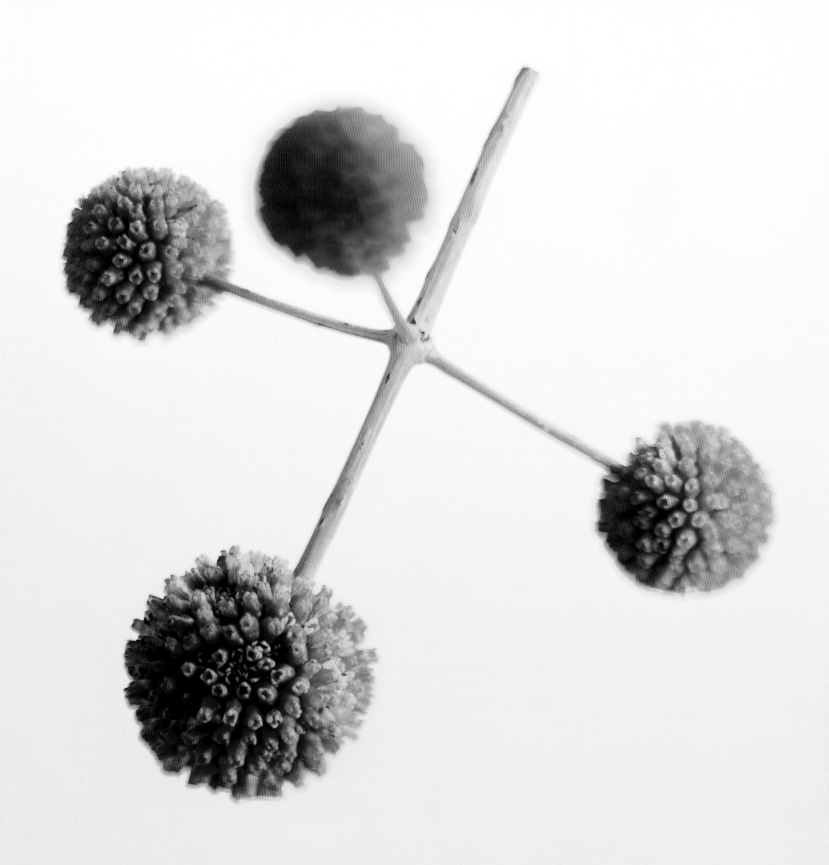

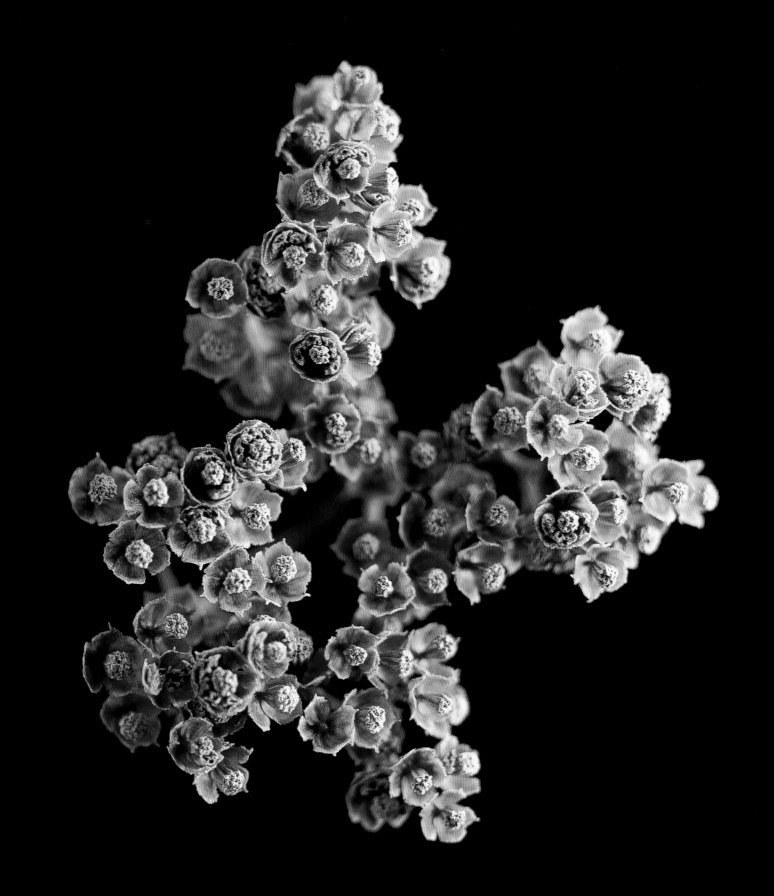

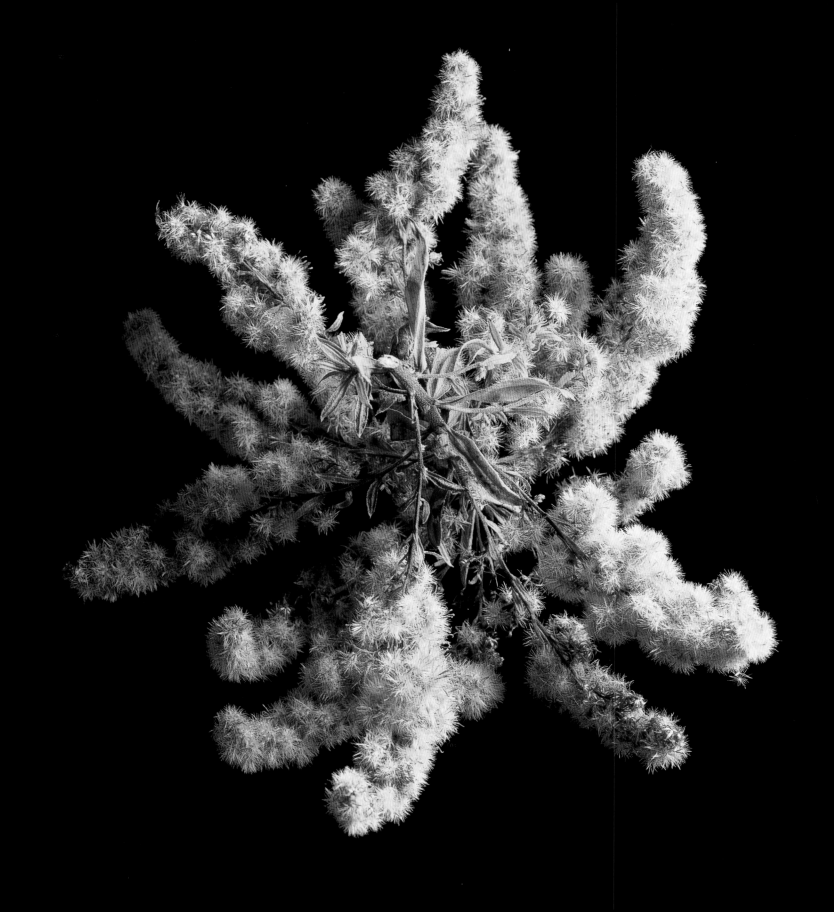

wherever

weeds

won't grow

let man

beware

to go

wherever

need

won't grow

just

BEWARE

to go

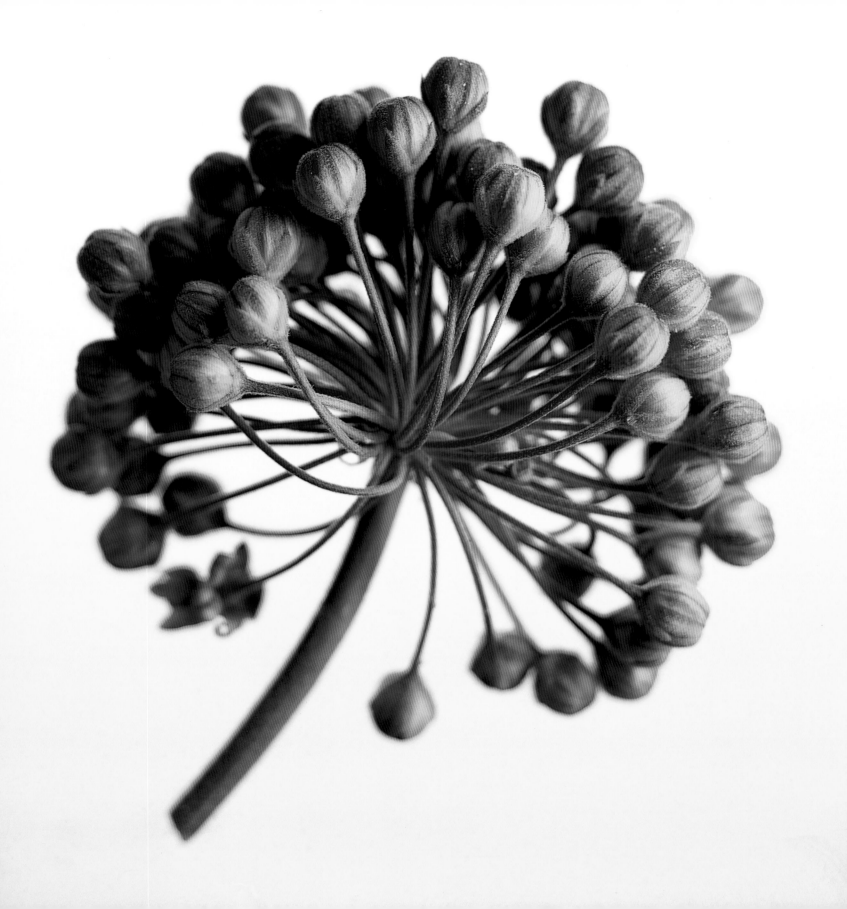

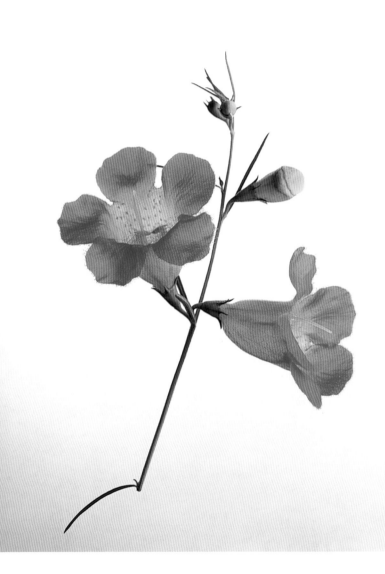

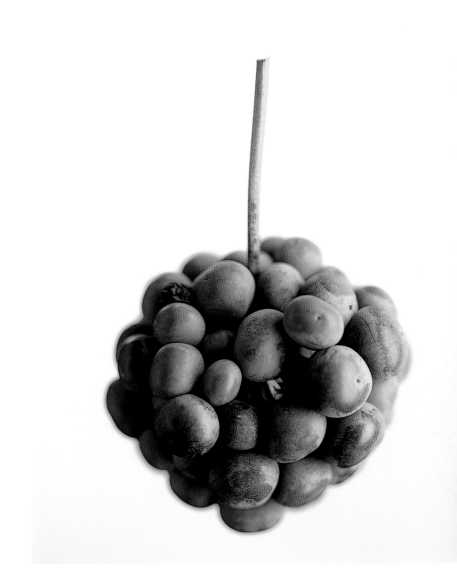

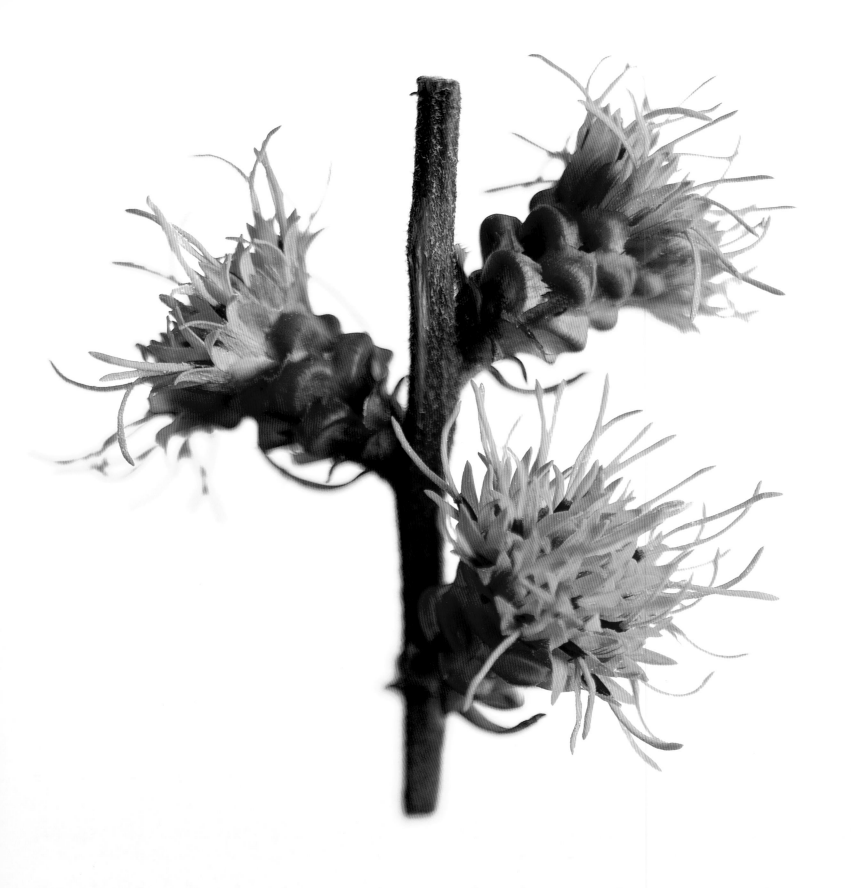

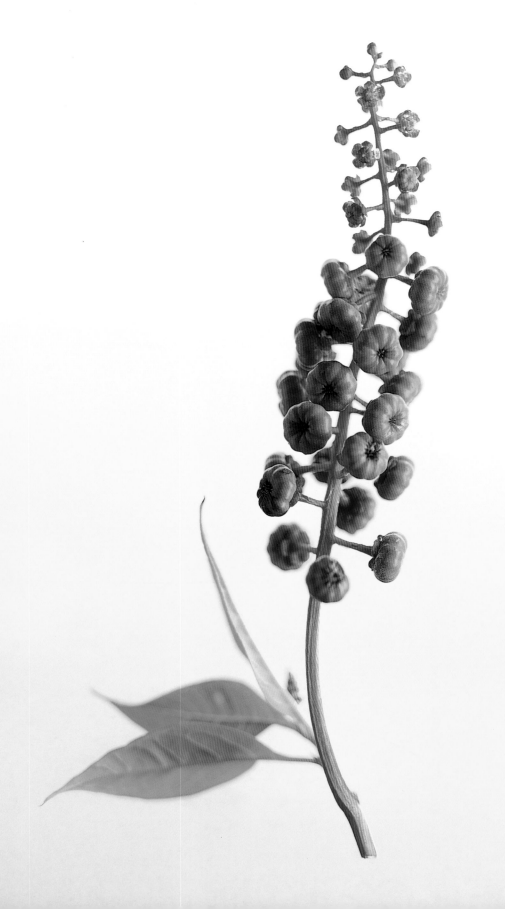

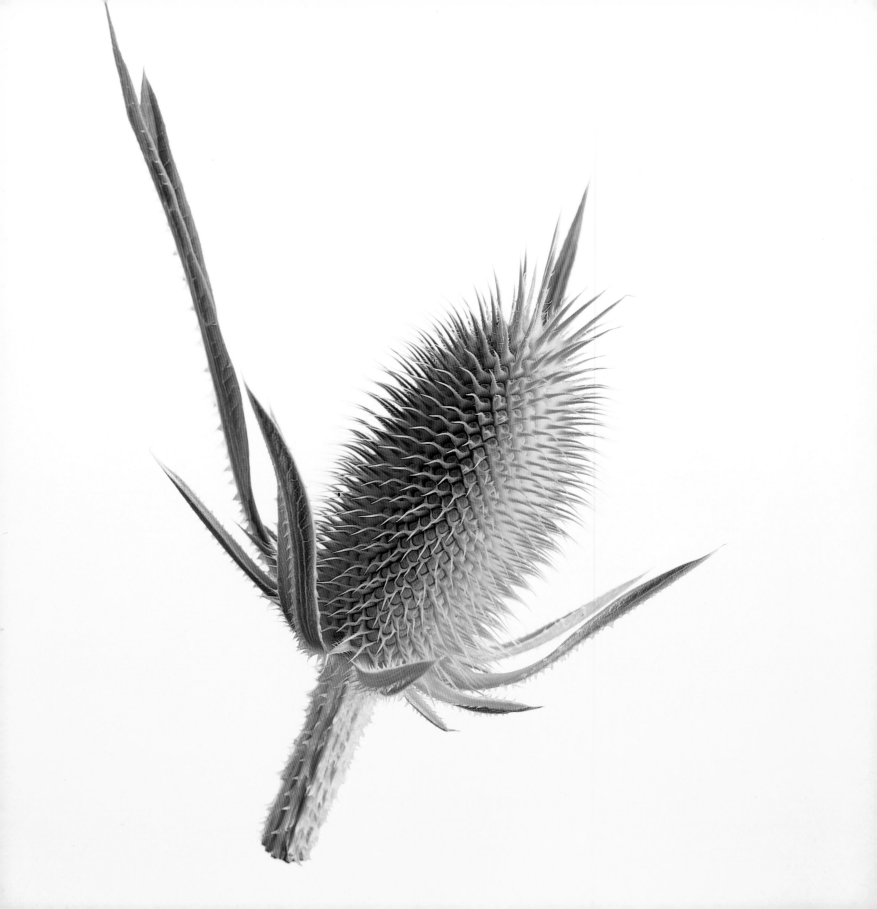

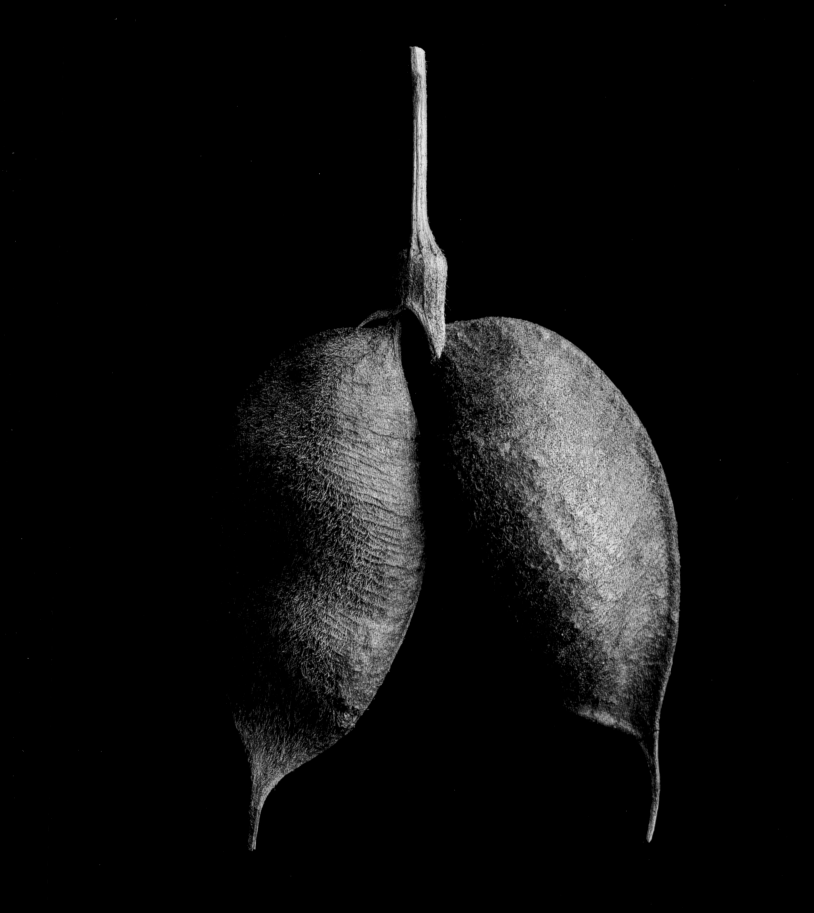

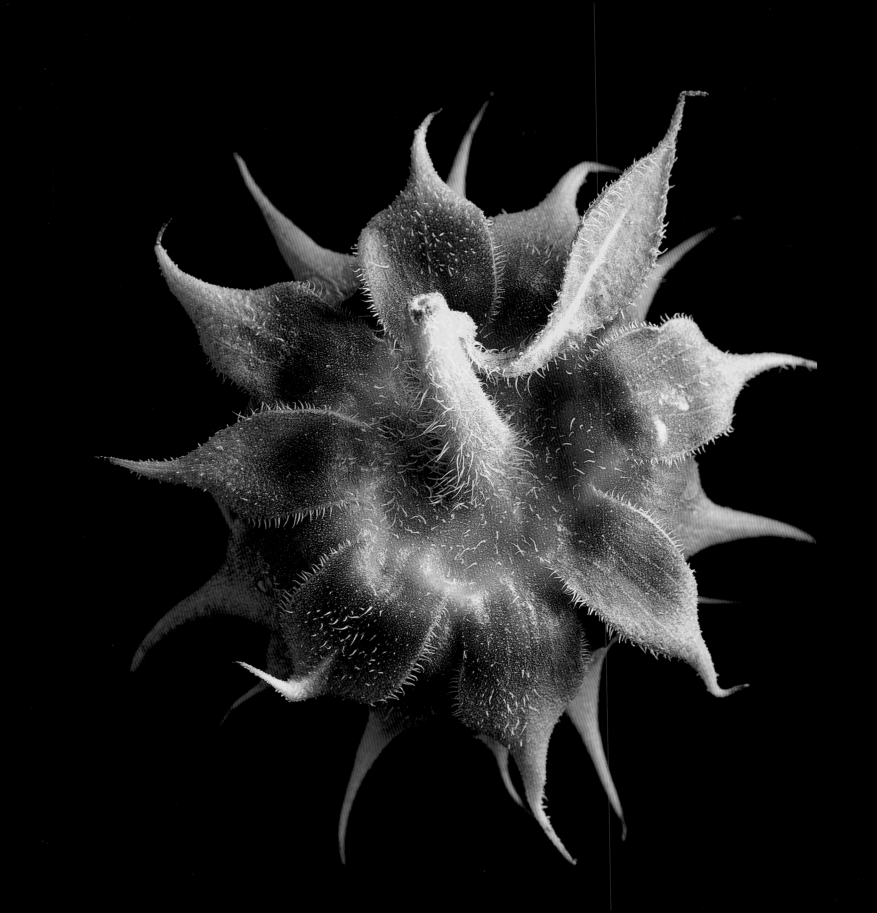

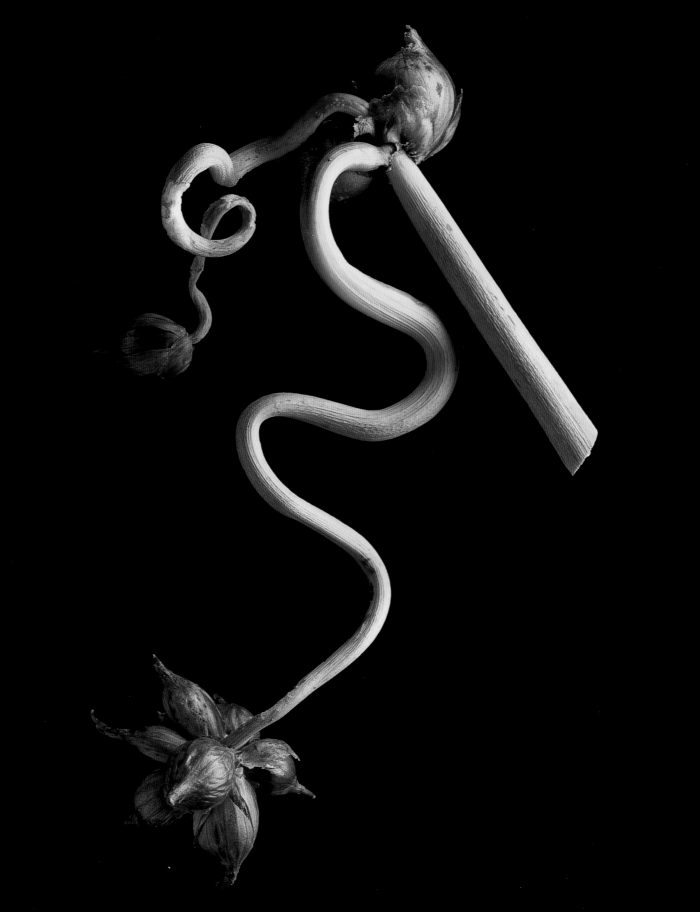

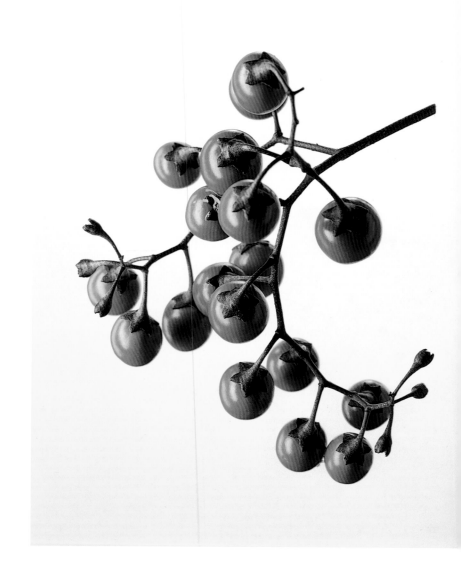

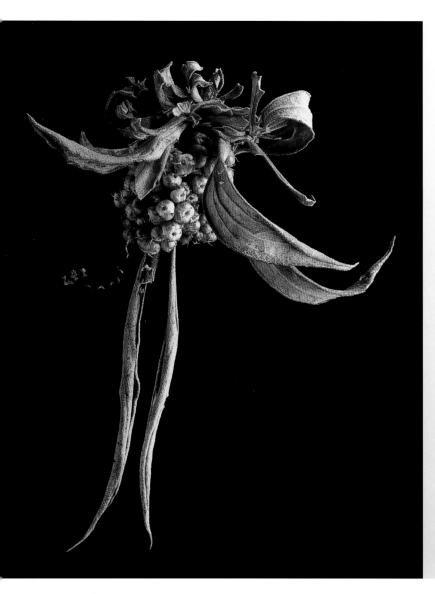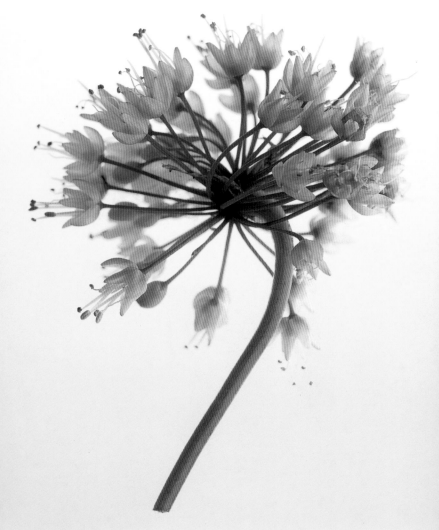

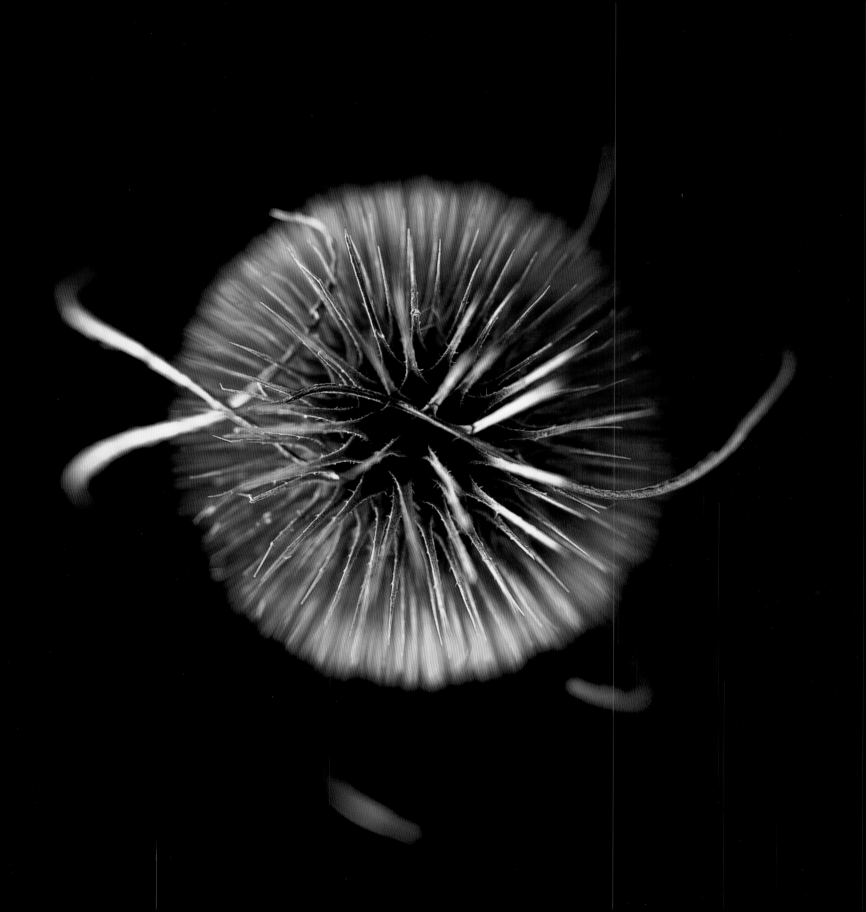

a world
bathed in
poison
cleared of the
unwanted
wear
widows
WEEDS

a world

battered in

poison

cleared of the

unwary

wears

widows

WEEDS

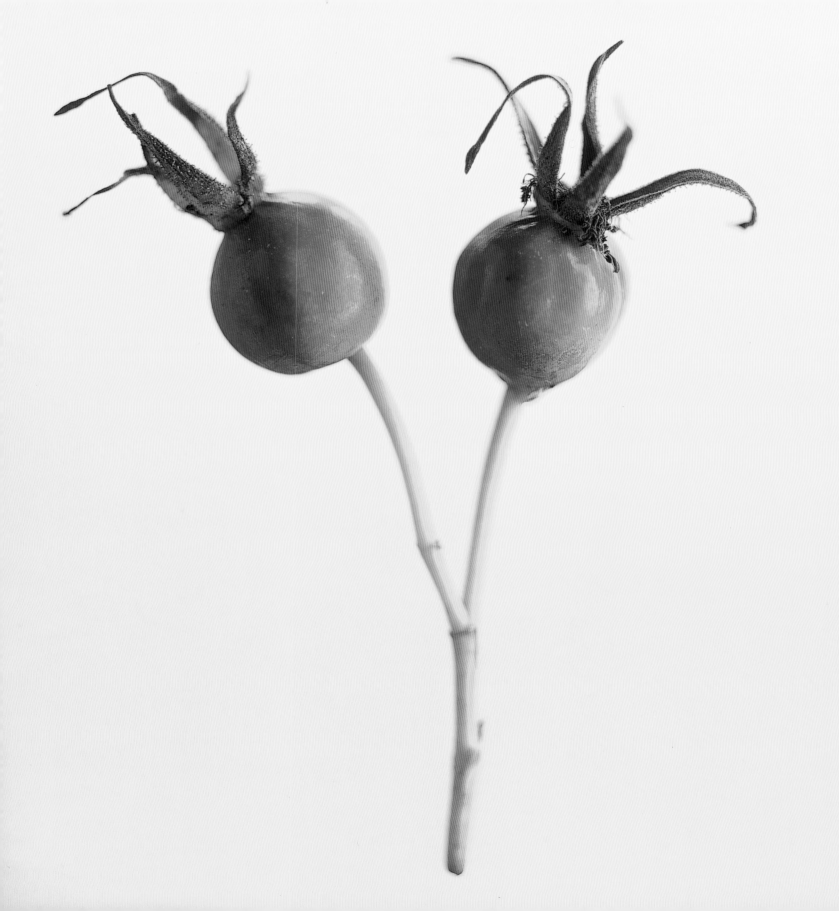

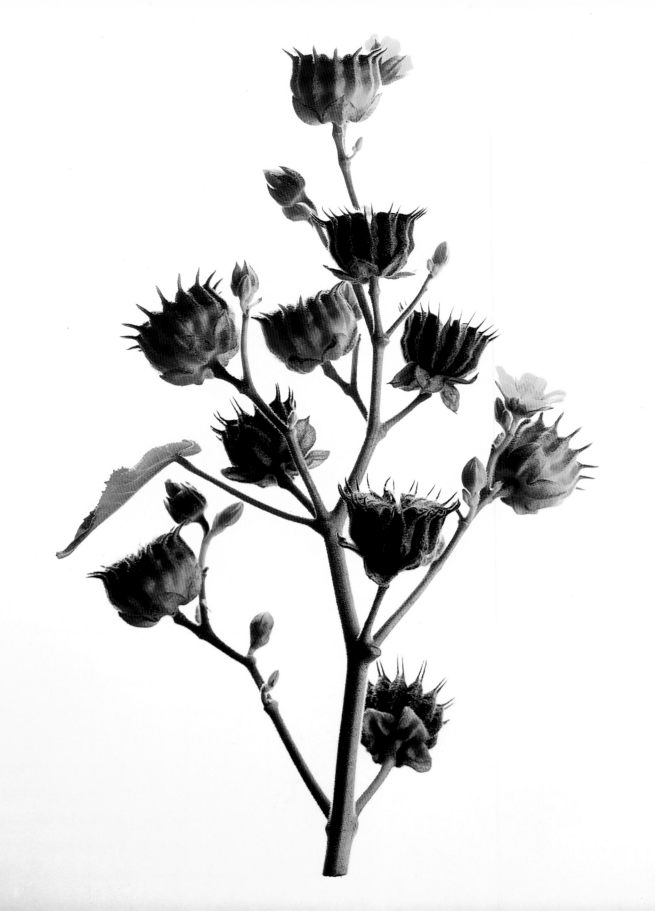

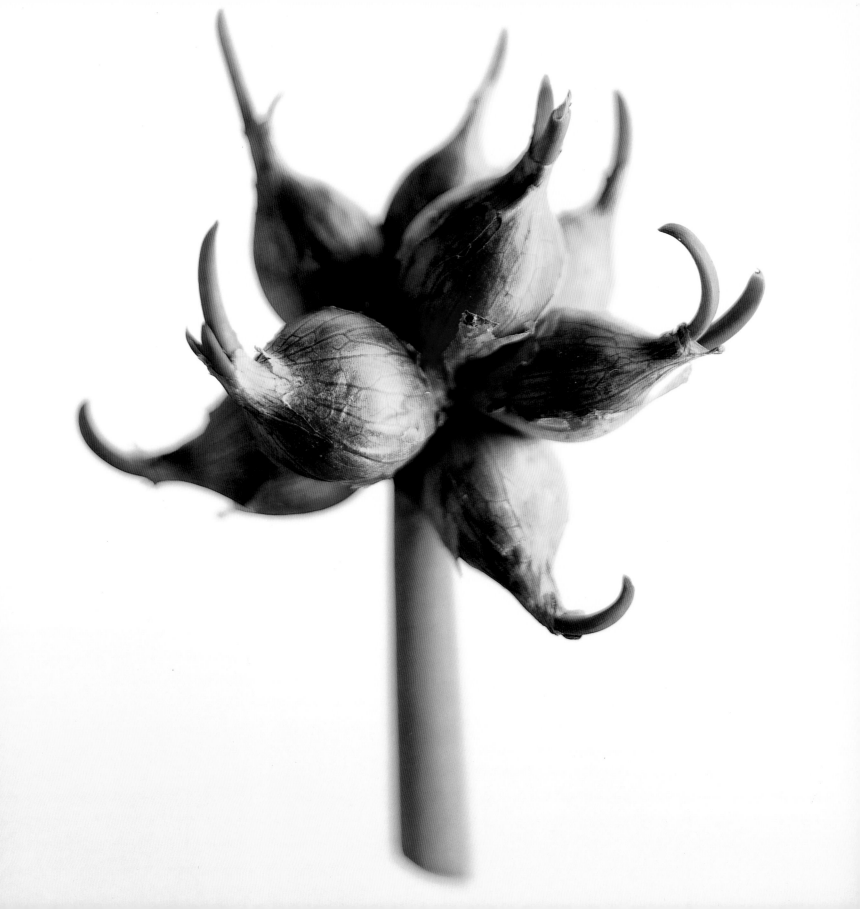

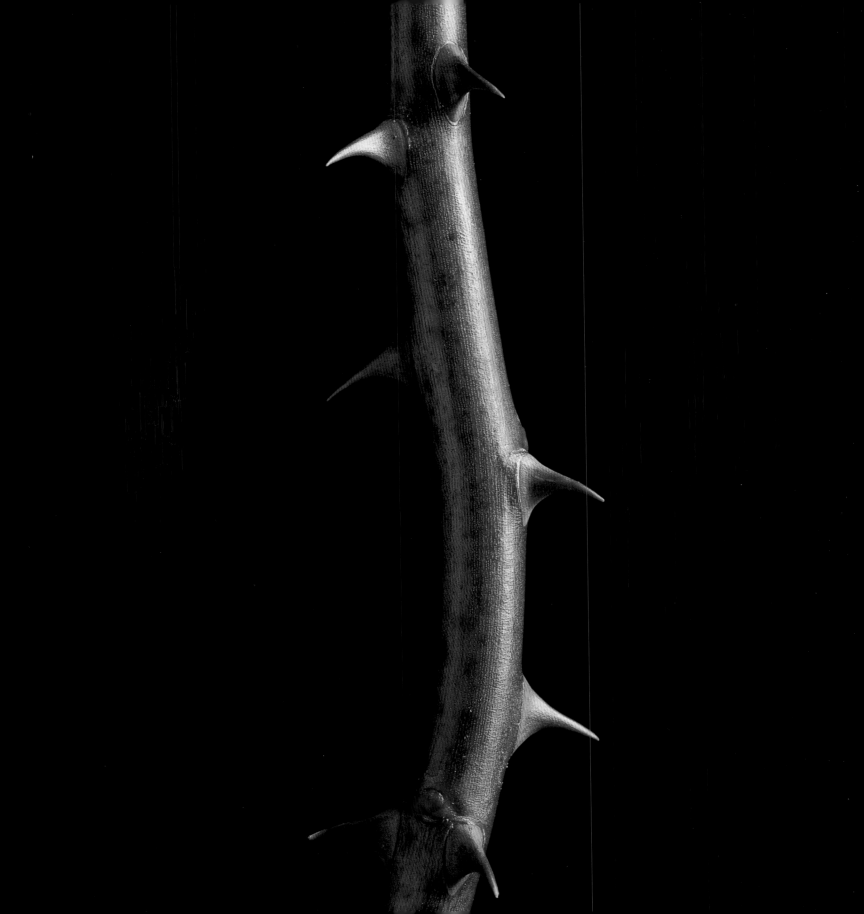

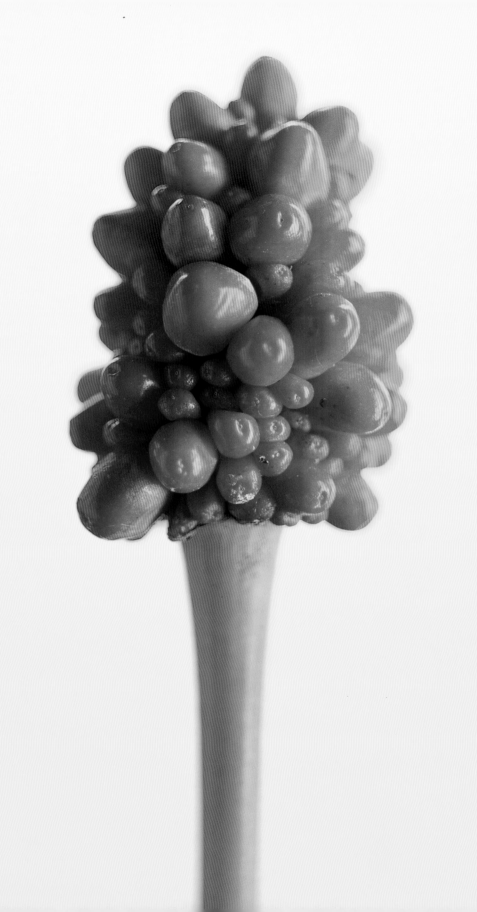

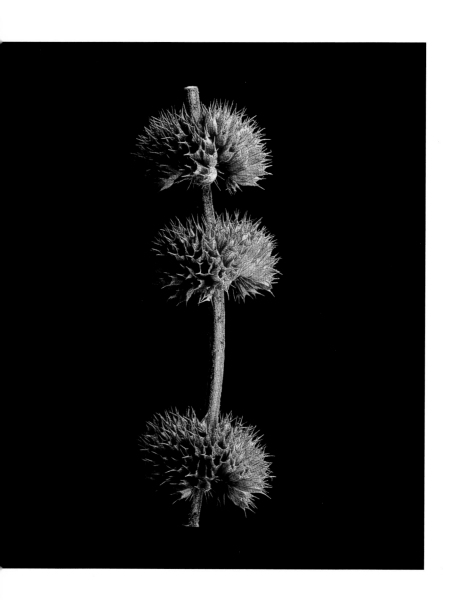

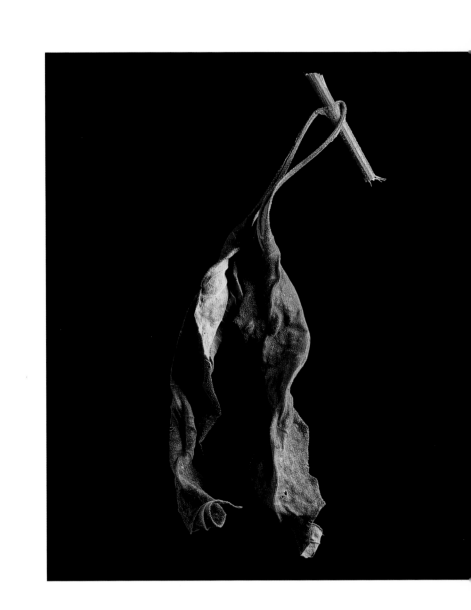

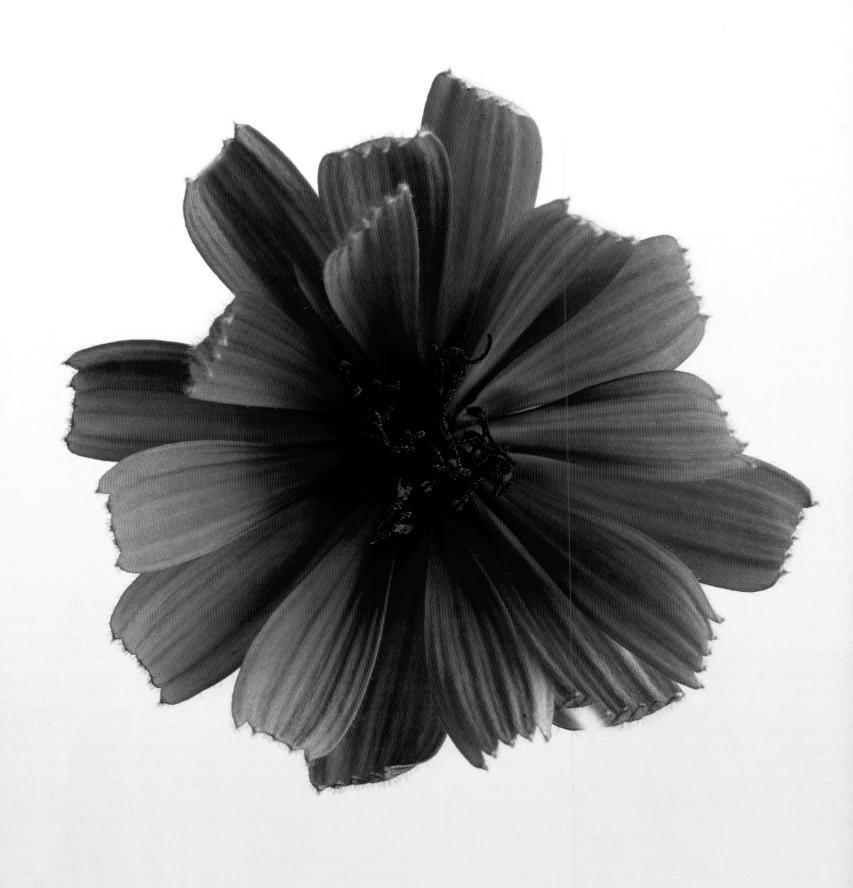

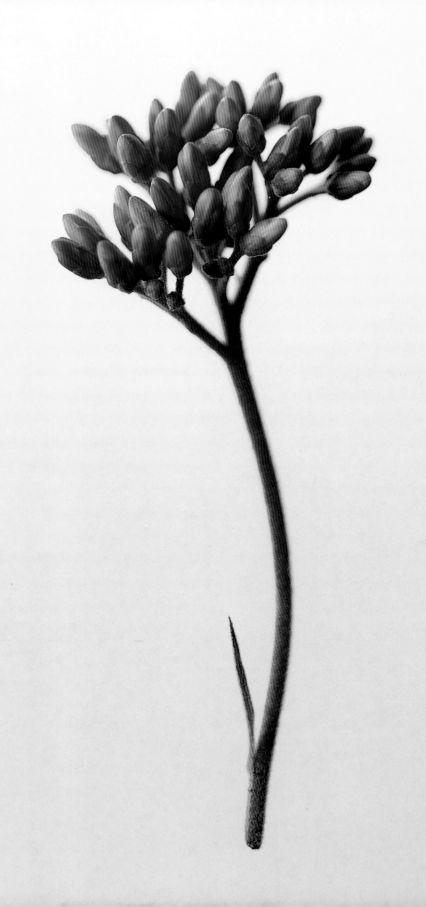

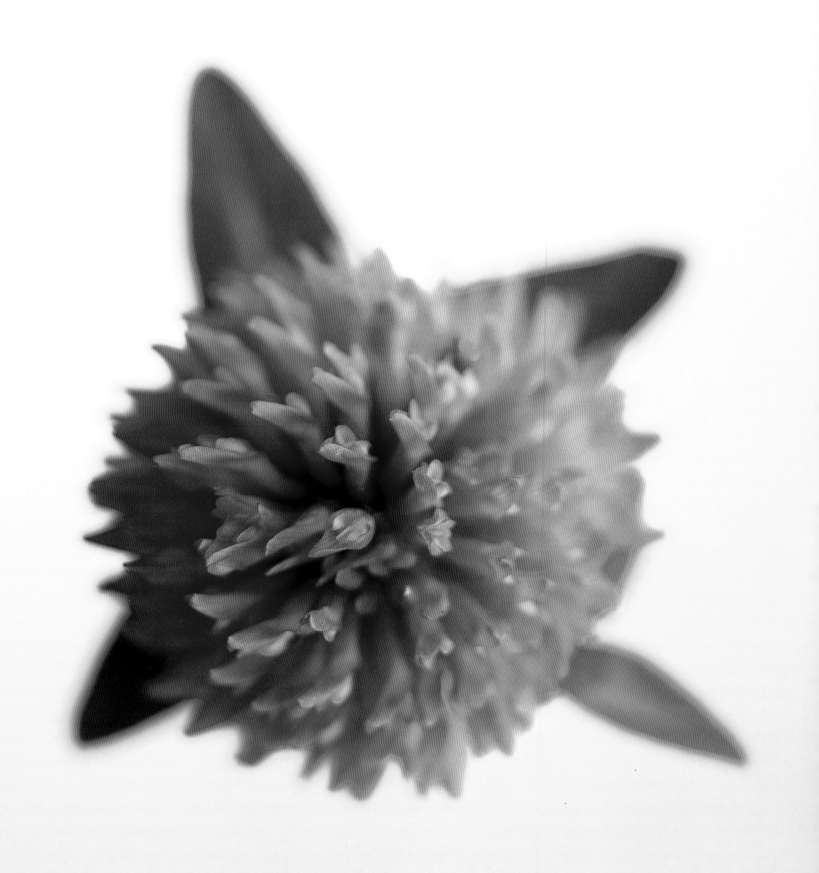

the weed
useless
AND undesirable
suggests
man's
essence

the weed useless and undesirable suggests maine essence

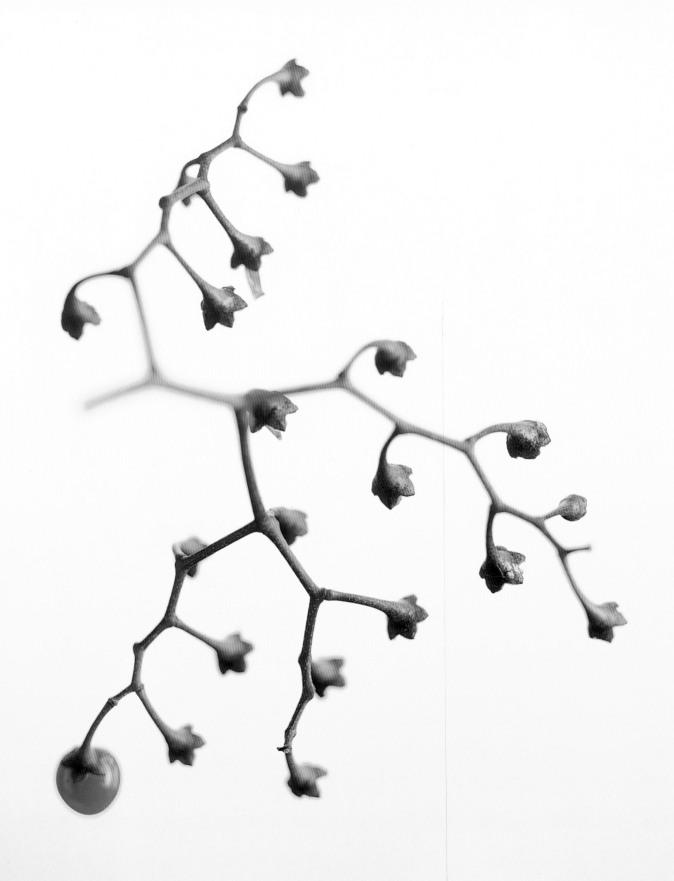

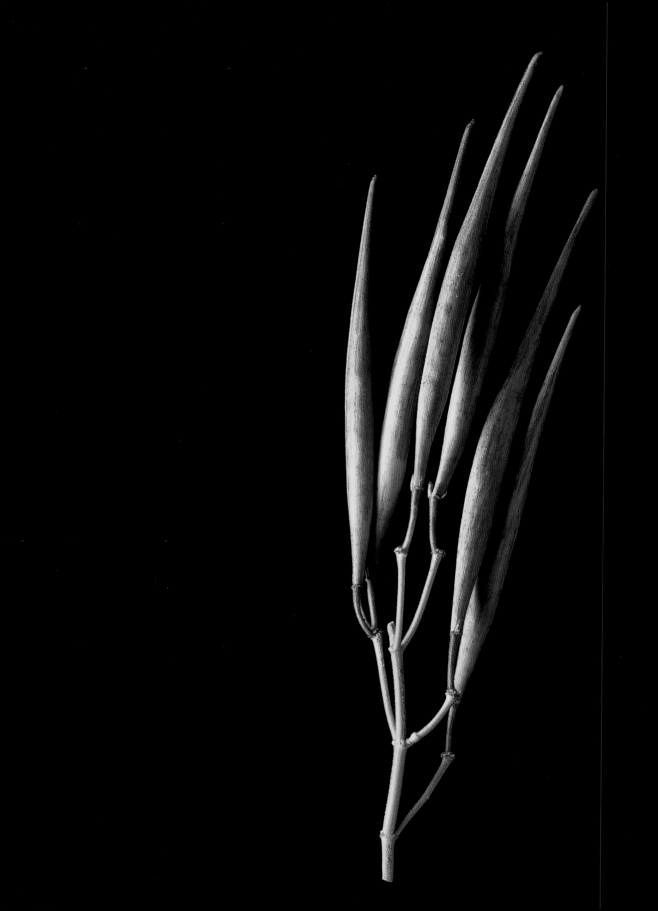

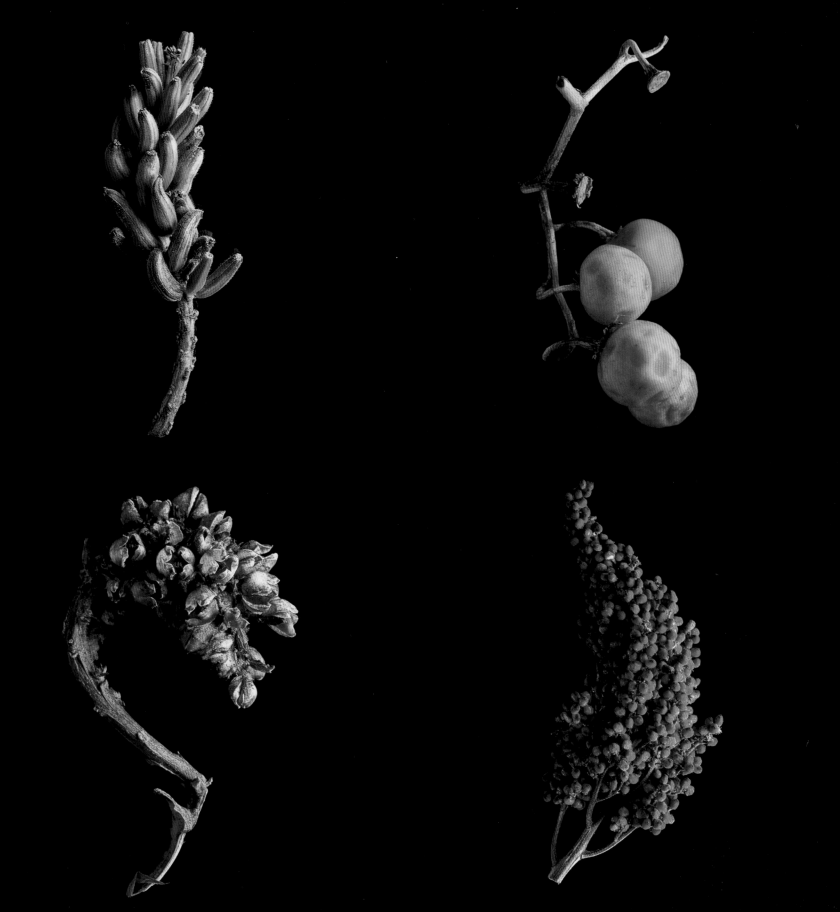

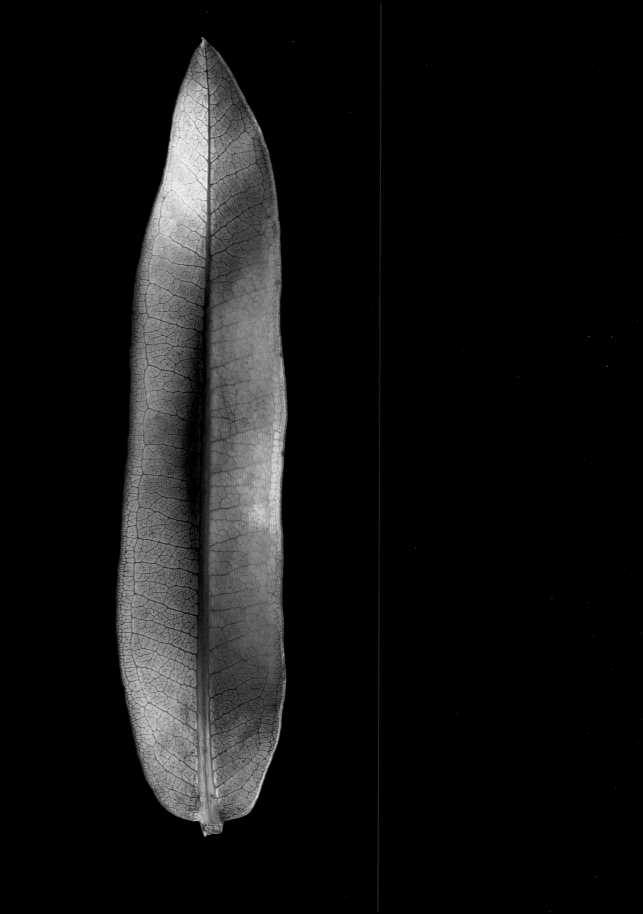

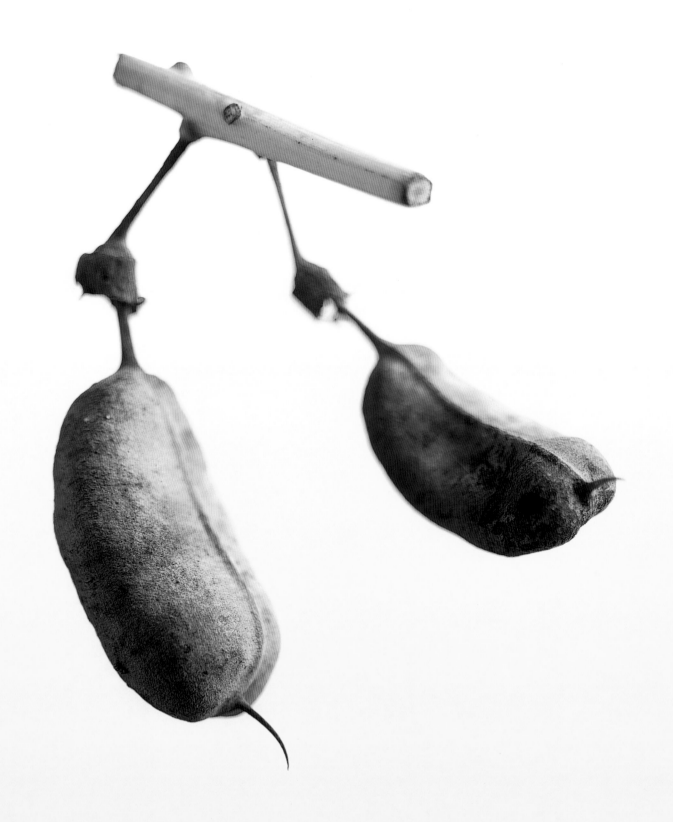

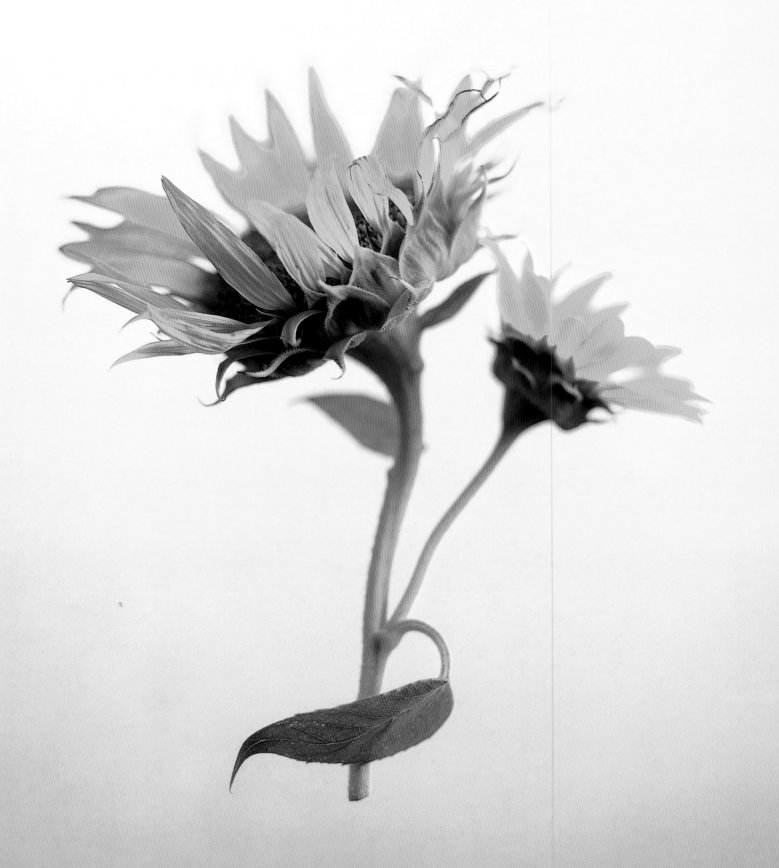

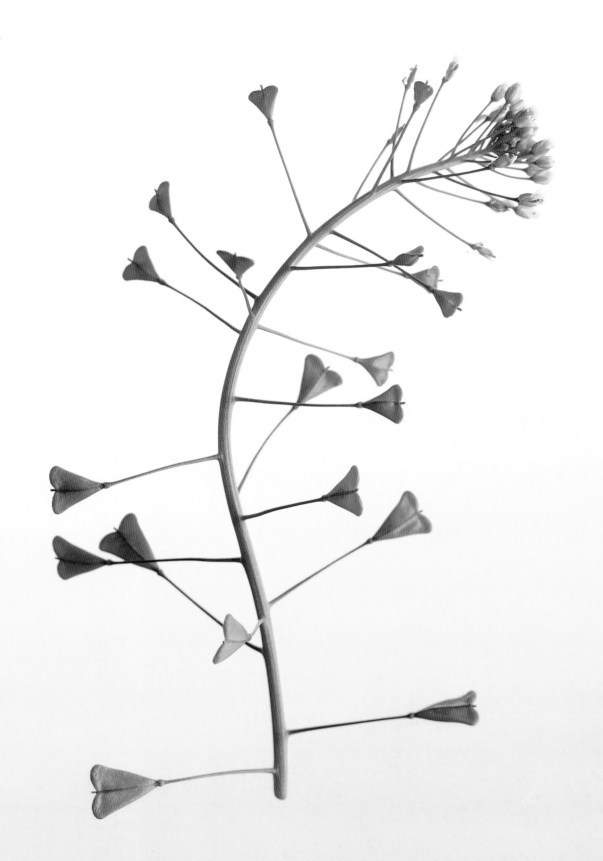

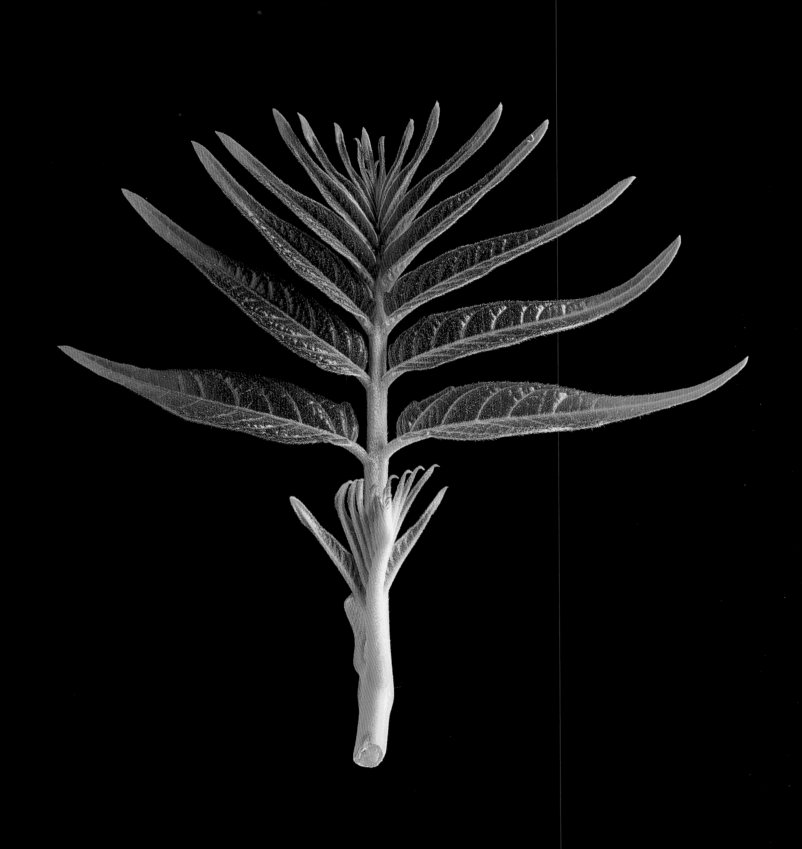

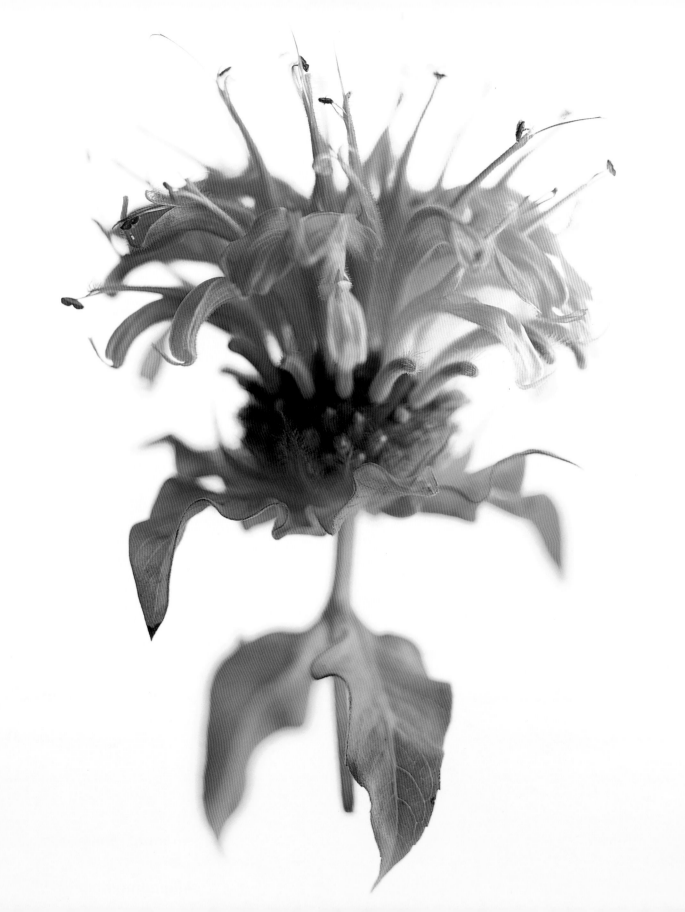

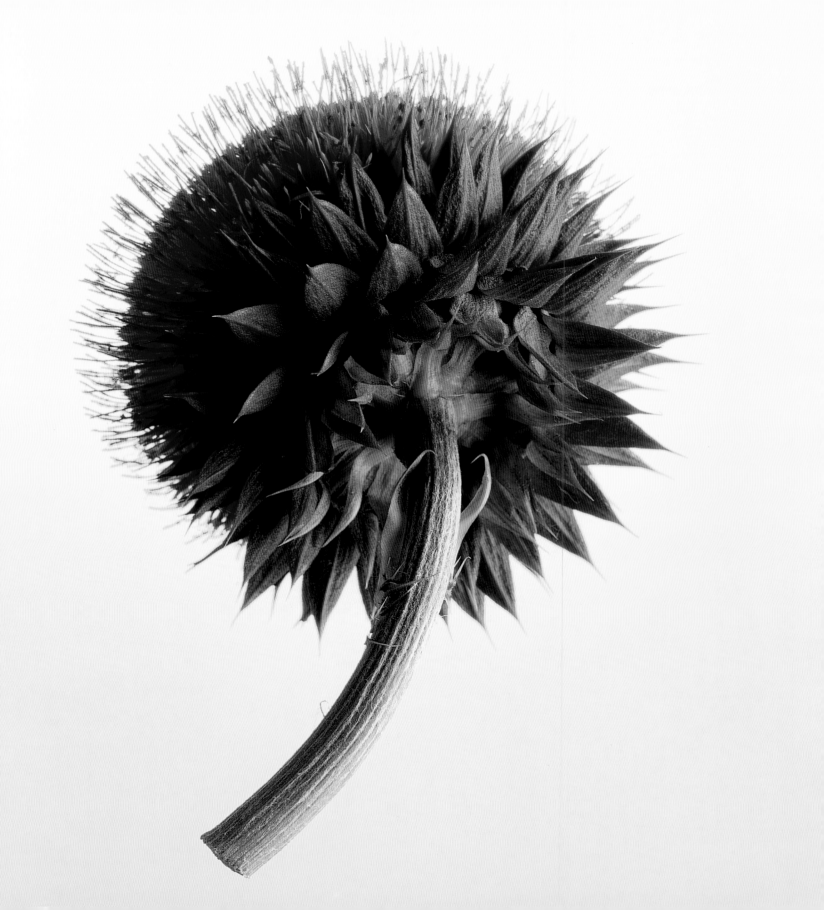

Waiting
pAtiently
the weeD
persists
for a day
beyond
mAn's hand

Waiting
pAtiently
Waited
persist
for a day
beyond
mAn's
in arid
parched

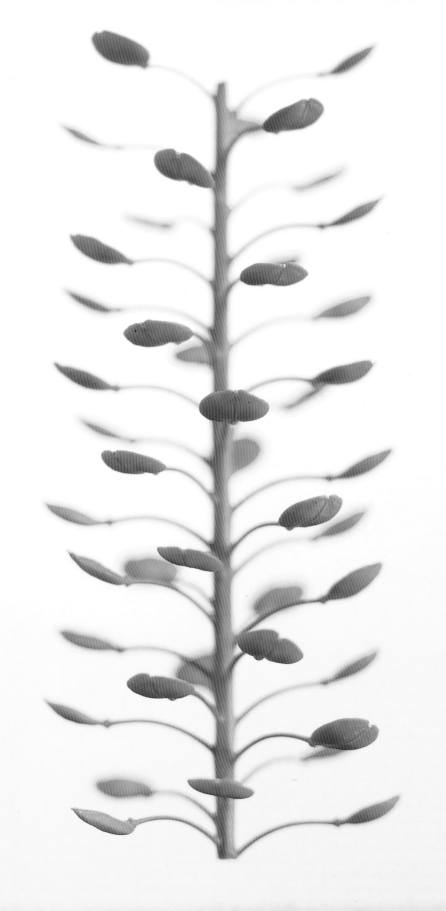

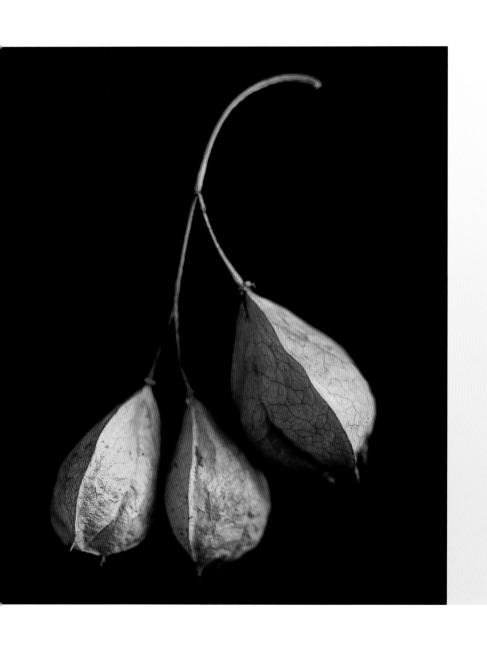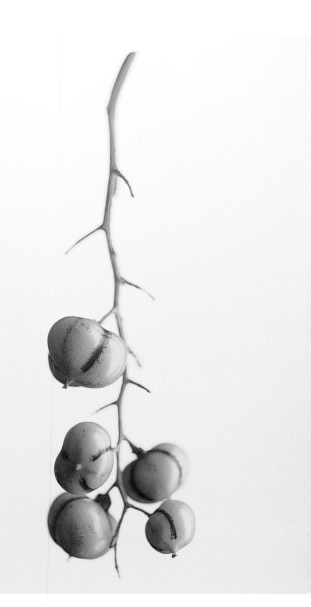

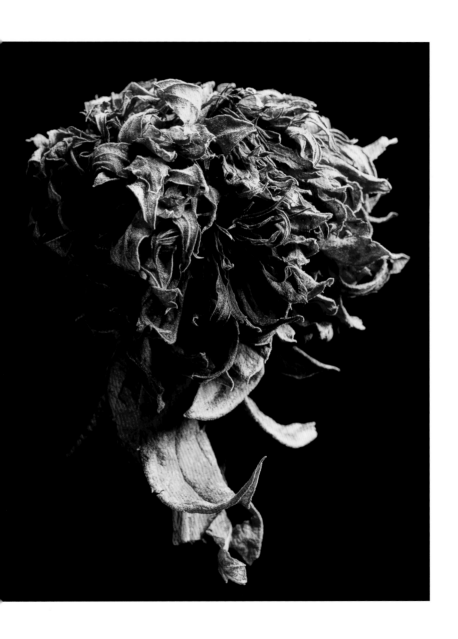

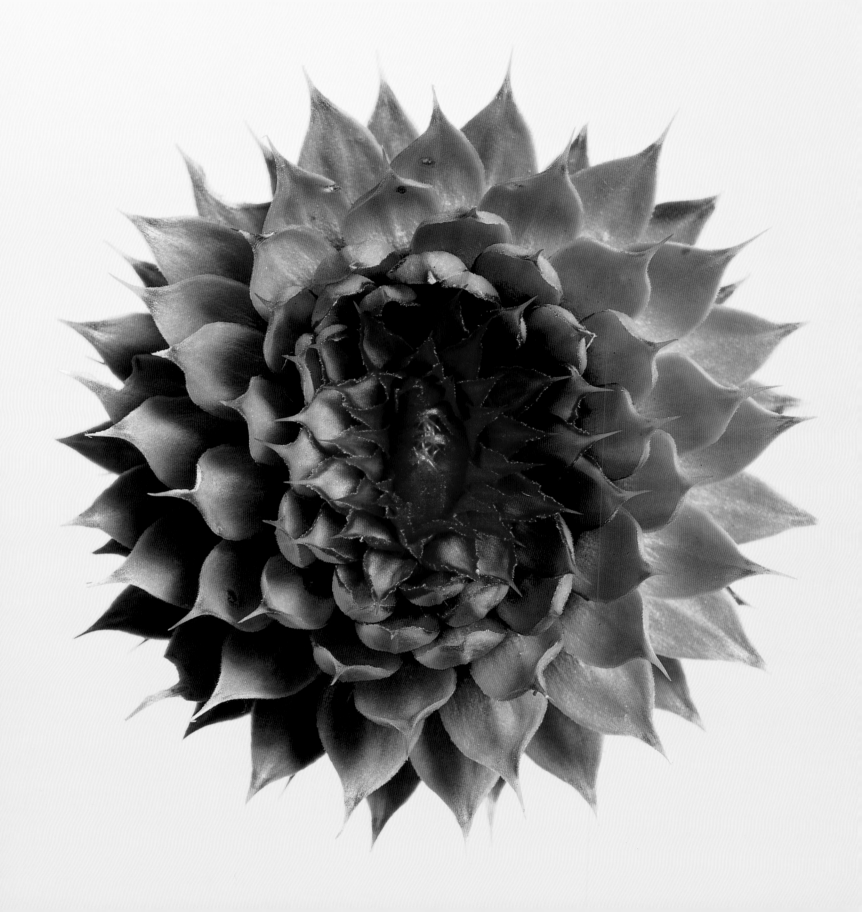

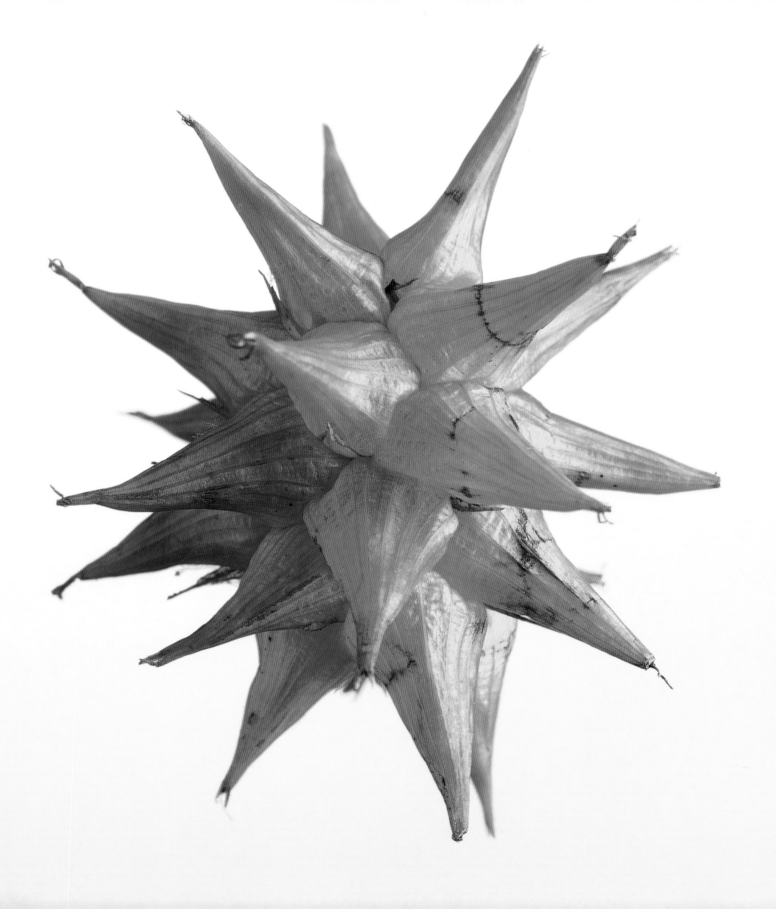

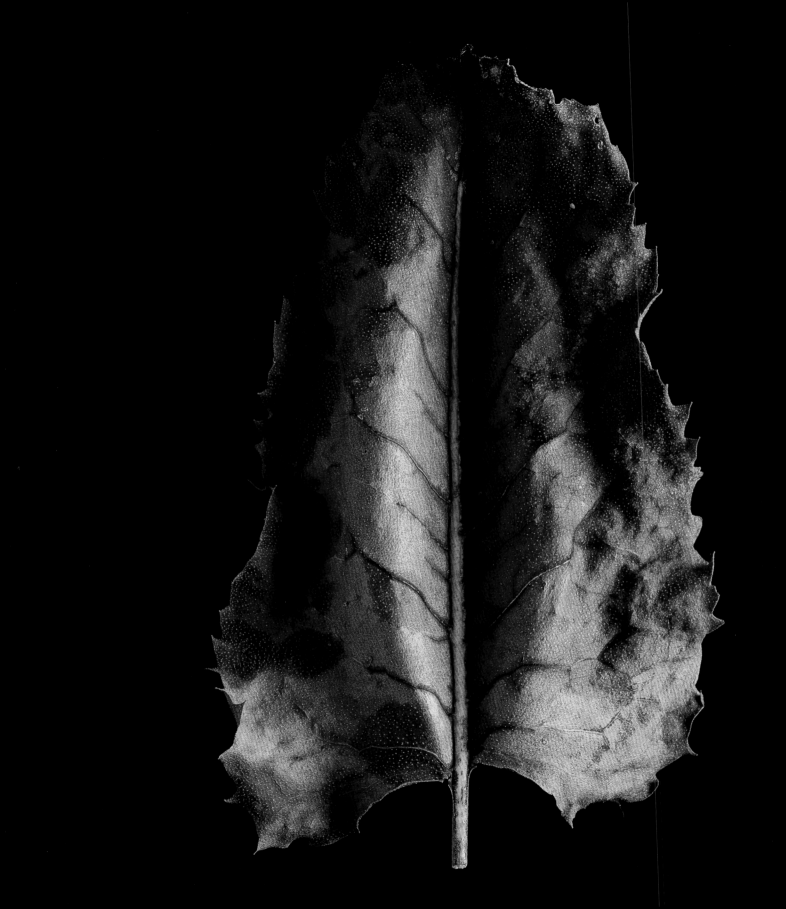

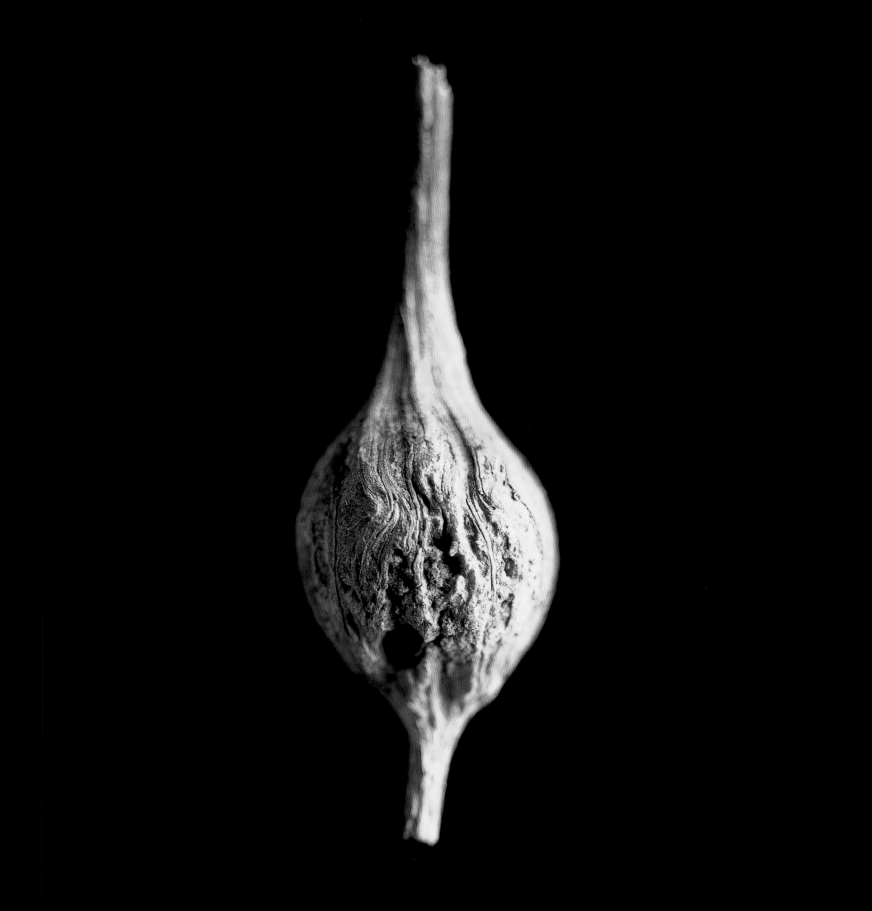

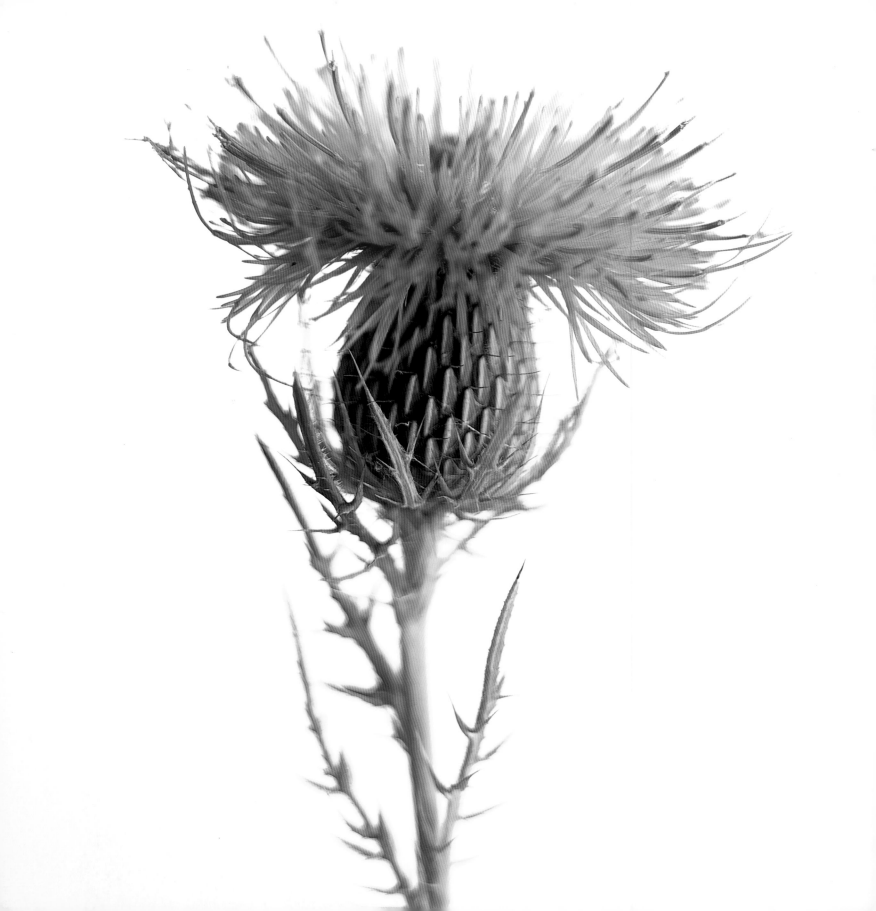

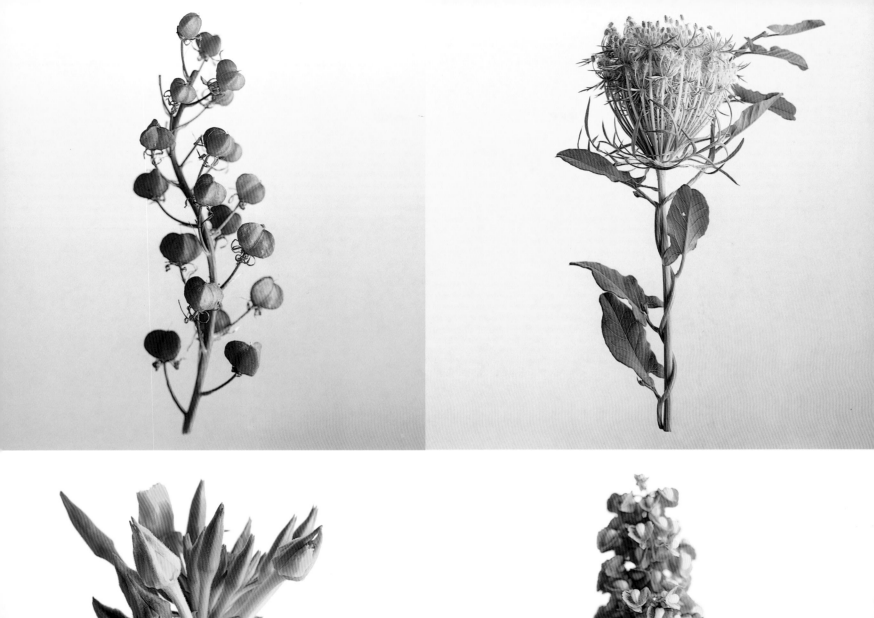
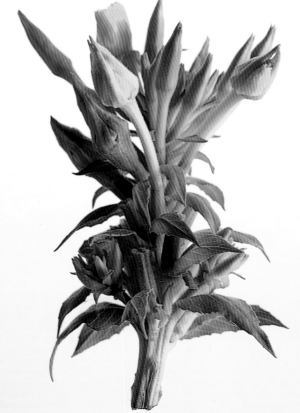
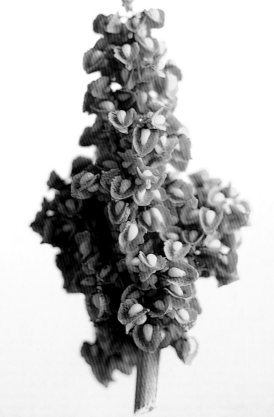

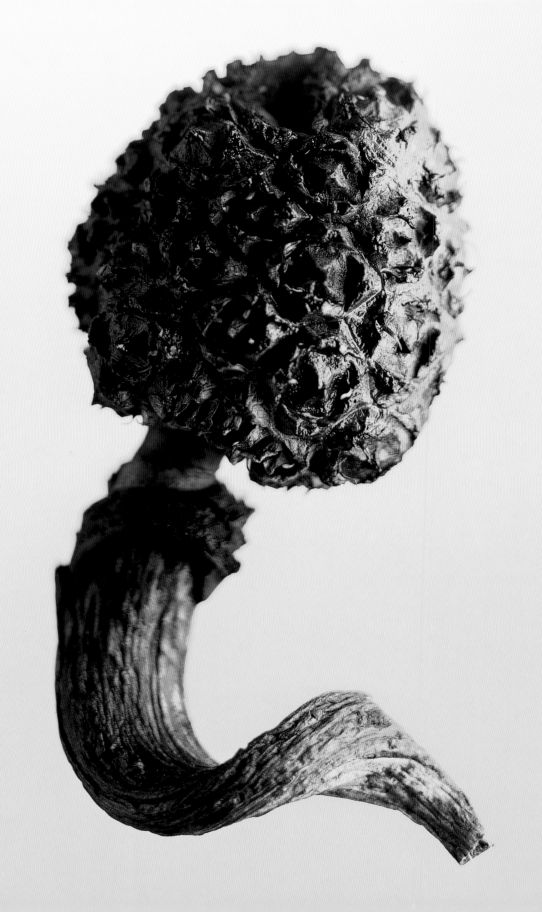

weeds are the strong and persistent creatures who live in weak circumstances

weeds are the strong and persistent creatures who weak live in circumstances

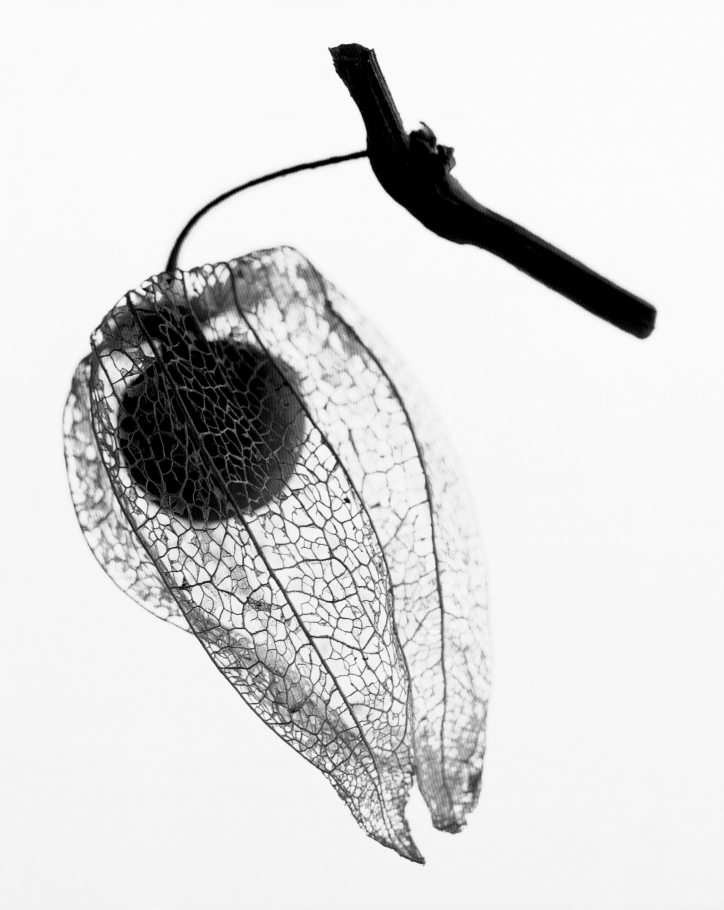

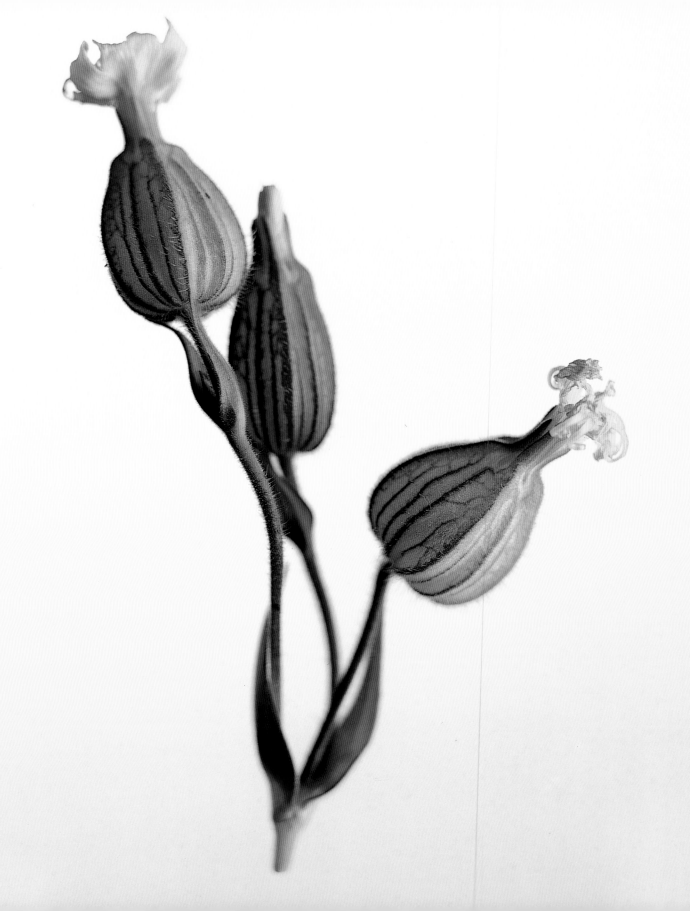

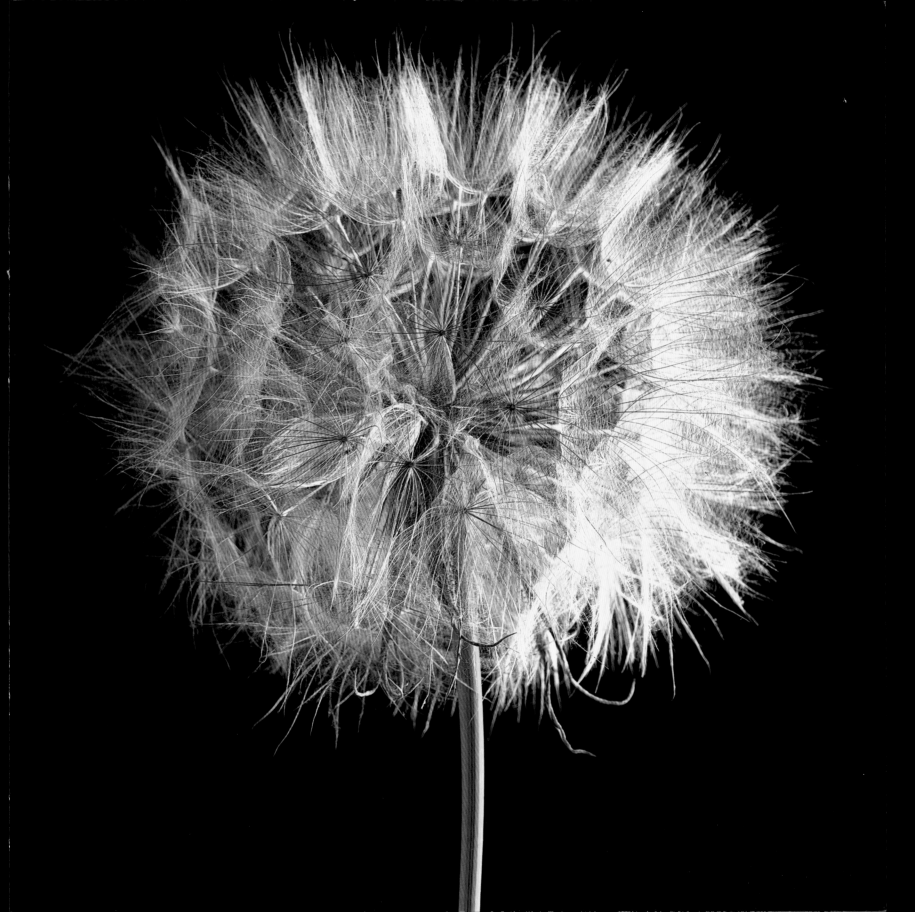

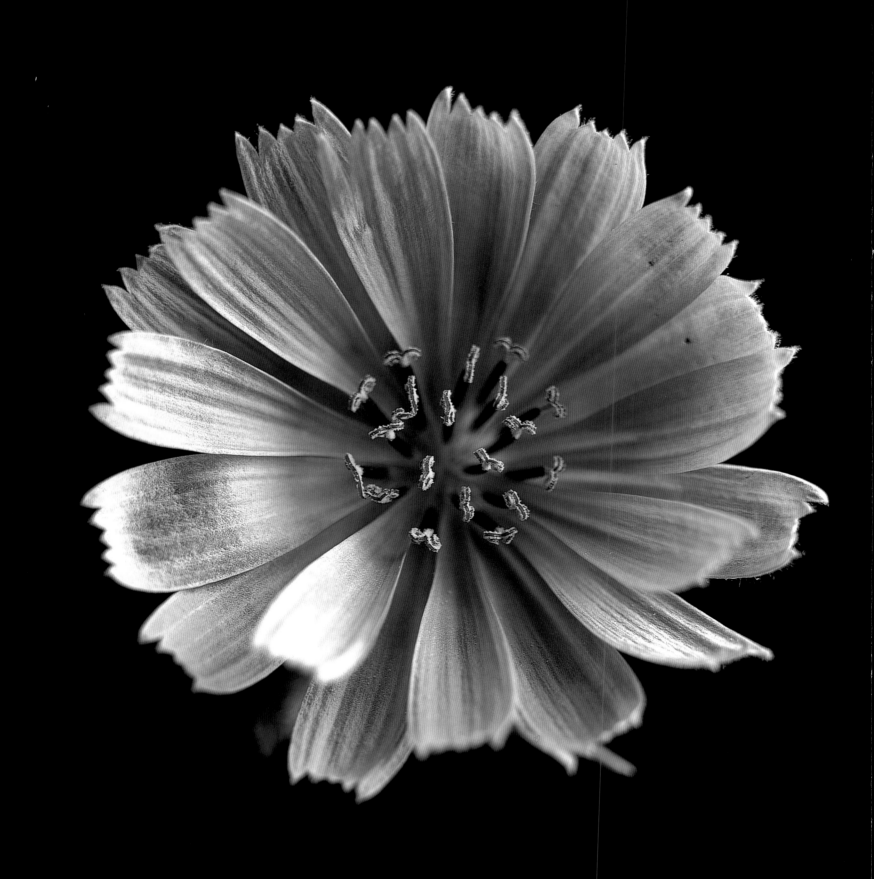

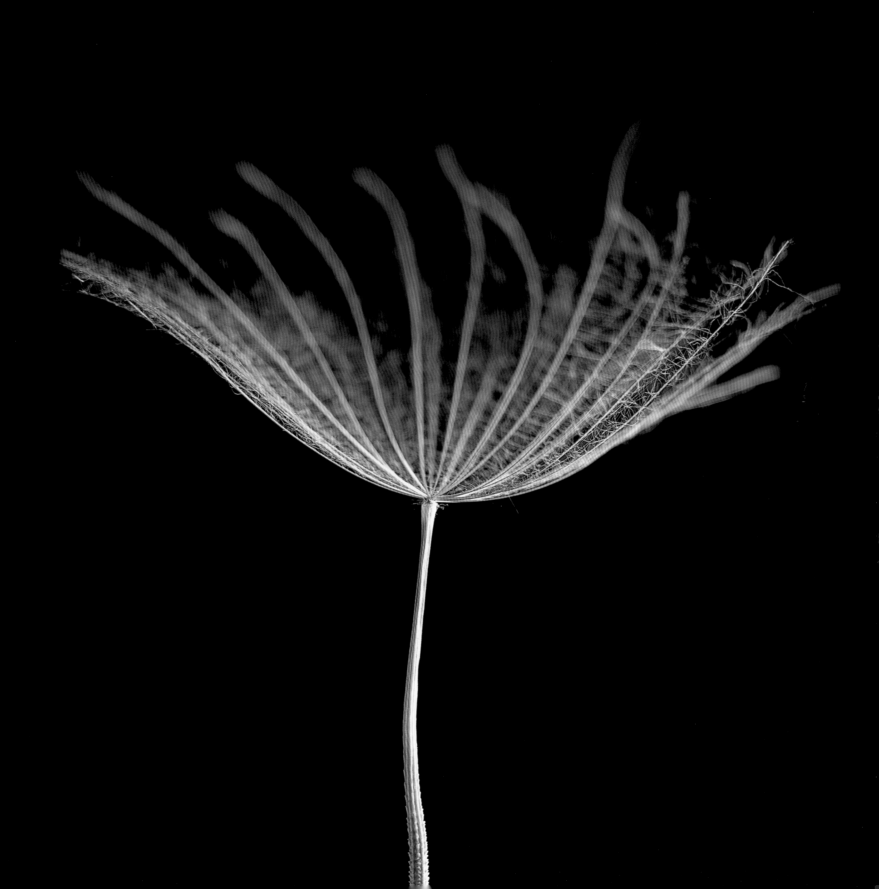

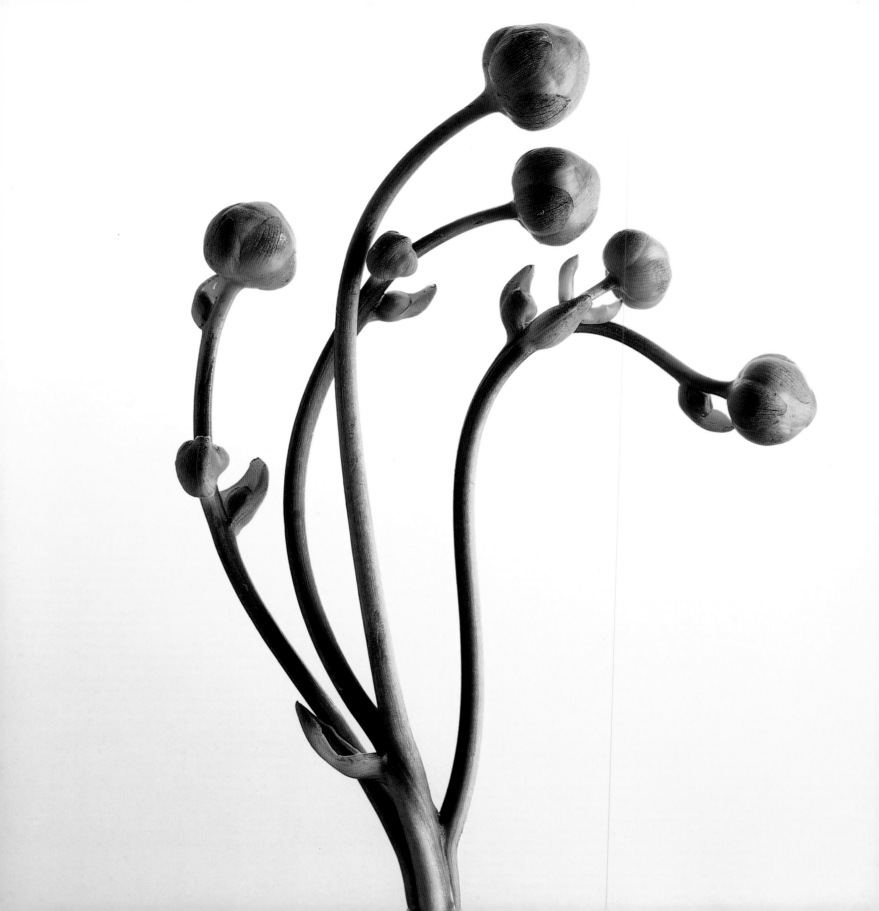

Howard Bjornson has run his own commercial photography studio in Chicago since 1980 and has exhibited his work in several shows. He has discovered through the creation of this book, that one needn't travel the world to find untamed natural beauty. Most of the weeds for this collection were gathered within a few miles of his studio.

red osier
Cornus stolonifera

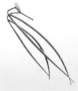

intermediate Dogbane
Apocynum x medium

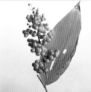

false solomon's seal
Smilacina racemosa

buttonbush
Cephalanthus occidentalis

wild Quinine
Parthenium integrifolium

common dandelion
Taraxacum officinale

agrimony
Agrimonia gryposepala

cream wild indigo
Baptisia leucophaea

wasp gall on goldenrod
Solidago

jimson weed
Datura stramonium

allium
Allium

western ironweed
Vernonia fasciculata

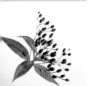

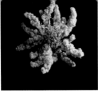

CANaᴅa goldenrod
Solidago canadensis

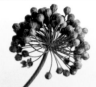

common milkweed
Asclepias syriaca

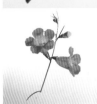

purple gerardiA
Agalinis purpurea

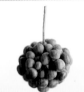

carrion flower
Smilax herbacea

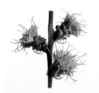

rough blazing sᴛaʀ
Liatris aspera

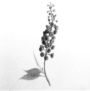

pokeweed
Phytolacca americana

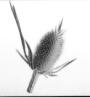

tEAsel
Dipsacus sylvestris

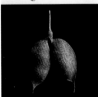

wHite wild indIgo
Baptisia leucantha

common sunflower
Helianthus annuus

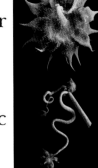

field garlic
Allium vineale

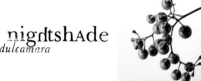

niɡʜtshᴀde
Solanum dulcamara

doᴅder on host plant
Cuscuta pentagona

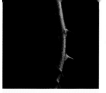

prairie rose
Rosa setigera

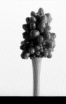

green dragon
Arisaema dracontium

nodding wild onion
Allium cernuum

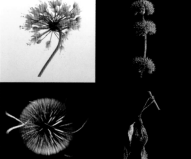

motherwort
Leonurus cardiaca

teasel
Dipsacus sylvestris

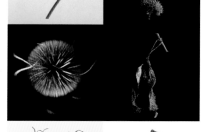

dried sunflower stAlk
Helianthus annuus

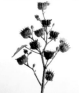

pasture rose
Rosa carolina

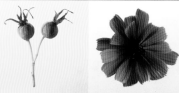

chicory
Cichorium intybus

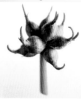

velvet leaf
Abutilon theophrasti

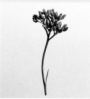

spotted joe-pye weed
Eupatorium maculatum

field garlic
Allium vineale

red clover
Trifolium pratense
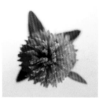

nightShadE
Solanum dulcamara

whorled milkweed
Asclepias verticillata

smooth sumac fruit
Rhus glabra

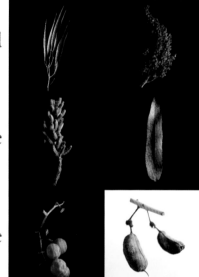

evening primrose
Oenothera biennis

prairie milkweed
Asclepias sullivanti

horse nettle
Solanum carolinense

Blue false indigo
Baptisia australis

common mullein
Verbascum thapsus

common sunflower
Helianthus annuus

sHepHerd's purse
Capsella bursa-pastoris
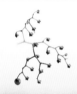

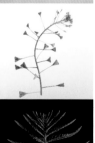

tree-of-heaven
Ailanthus altissima

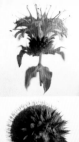

wild bergamot
Monarda fistulosa

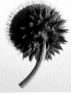

nodding thistle
Carduus nutans

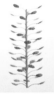

peppergrass
Lepidium virginicum

american bladdernut
Staphylea trifolia

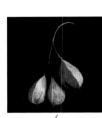

starry false solomon's seal
Smilacina stellata

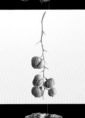

wasp gall
on dried goldenrod
Solidago

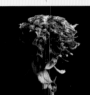

bull thistle
Cirsium vulgare

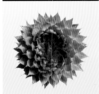

bur sedge
Carex grayi var. hispidula

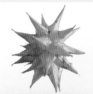

prairie dock
Silphium terebinthinaceum

gall on
canada goldenrod
Solidago canadensis

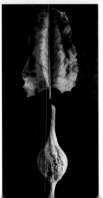